WREAKING HAVOC

How to Create FANTASY WARRIORS and WICKED WEAPONS

Chuck LUKACS ✠ Jim PAVELEC

Chris SEAMAN ✠ Thomas MANNING

IMPACT
CINCINNATI, OHIO
www.impact-books.com

ABOUT THE AUTHORS

Wreaking Havoc. Copyright © 2008 by Chuck Lukacs, Jim Pavelec, Chris Seaman and Thomas Manning. Manufactured in China. All rights reserved. No part of this book may be reproduced in any form or by any electronic or mechanical means including information storage and retrieval systems without permission in writing from the publisher, except by a reviewer who may quote brief passages in a review. Published by IMPACT Books, an imprint of F+W Publications, Inc., 4700 East Galbraith Road, Cincinnati, Ohio, 45236. (800) 289-0963. First Edition.

Other fine IMPACT Books are available from your local bookstore, art supply store or visit our website at www.fwpublications.com.

12 11 10 09 08 5 4 3 2 1

DISTRIBUTED IN CANADA BY FRASER DIRECT
100 Armstrong Avenue
Georgetown, ON, Canada L7G 5S4
Tel: (905) 877-4411

DISTRIBUTED IN THE U.K. AND EUROPE BY DAVID & CHARLES
Brunel House, Newton Abbot, Devon, TQ12 4PU, England
Tel: (+44) 1626 323200, Fax: (+44) 1626 323319
Email: postmaster@davidandcharles.co.uk

DISTRIBUTED IN AUSTRALIA BY CAPRICORN LINK
P.O. Box 704, S. Windsor NSW, 2756 Australia
Tel: (02) 4577-3555

Library of Congress Cataloging in Publication Data
Wreaking havoc : how to create fantasy warriors and wicked weapons / by Chuck Lukacs ... [et al.]. -- 1st ed.
 p. cm.
 Includes index.
 ISBN-13: 978-1-60061-000-4 (pbk. : alk. paper)
 1. Fantasy in art. 2. Heroes in art. 3. Weapons in art. 4. Painting--Technique. I. Lukacs, Chuck
ND1460.F35W74 2008
751.4--dc22 2007040935

Edited by Mary Burzlaff
Designed by Wendy Dunning
Production coordinated by Matt Wagner

CHUCK LUKACS has been illustrating for the science-fiction and fantasy community for the past seven years. He's spent the last five years working in oils, but he has worked in many different crafts, from historical book-craft, papermaking, and wood engraving to ceramics.

In terms of philosophical influence, Buddhism, Taoism and a number of world mythologies have played rather large roles in Chuck's art. He is a huge fan of jazz music and comedy. He also keeps on top of global political and economic news and is an activist and advocate of the Progressive Peace movement.

Chuck lives happily with his wife and dog and is about as sane as a chickpea sandwich. Lacking any useful social skills, and being prone to extraordinary lapses of common sense, he stays up late into the morning dreaming his daft-wit little dreams, trying his best to bring them into light. When he isn't pushing paint around, he's practicing traditional archery, thinking about solar- and wind-power projects, craft brewing or playing with manned kites, musical effects, instruments and windup toy design. Visit Chuck at his website www.chucklukacs.com.

ACKNOWLEDGMENTS

Gracious thanks to all my friends and family, including Jim, Chris, Thomas, all the fine folks at F+W Publications and the art directors and editors from Wizards of the Coast and Alderac Entertainment Group for their support over the years. Also thanks to fans who support the arts, and believe that artists can make positive change in our society and our planet.

DEDICATION

To my beautiful wife, Melanie: were it not for your hard work, encouragement and understanding, I would not be able to bring my images to light.

JIM PAVELEC

In 1974, after he viewed *The Exorcist* at the tender age of two, a pattern began to evolve in young Jim Pavelec's life, one that he cultivates to this day. That pattern is an ever increasing love of imagery most foul. Demons and monsters and devils of all sorts consume his every waking hour, and serenade him throughout the night.

But what would be the best way for this fledgling neophyte to express his love? The options were many, but his eventual choice: paper and pencil, and a little paint, too.

Off on his own, the caterpillar began to change into a butterfly. Armed with his visual encyclopedia of artists past, a firm hatred of humanity and the desire to dominate, Jim set off into the gaming world where he slaved tirelessly for companies such as Wizards of the Coast on their *Magic: The Gathering* and *Dungeons & Dragons* lines, and Upper Deck on their *World of Warcraft* game. Most recently he produced *Hell Beasts,* a how-to book for IMPACT Books.

At the present time Jim lives a comfortable life with his girlfriend, Aimee, in a house full of that imagery most foul, which makes him happiest of all.

ACKNOWLEDGMENTS

I would like to thank Thomas, Chuck and Chris for all of their hard work on this book. Seeing their outstanding work motivated me to work harder. I would also like to thank my parents for allowing me the freedom as a child to pursue the things that interested me, even if they didn't really understand or like them, and for instilling in me an unbreakable work ethic. My sincerest gratitude goes to Aimee for being the best girl there is.

Finally, I would like to thank all of the people at IMPACT Books, from editorial and design to sales and marketing: you guys are the best. Thanks again for the opportunity to wreak havoc under your banner.

DEDICATION

This book is dedicated to the late Thomas Manning. A day does not and will not pass that I do not think of him. I have never met a person as knowledgeable about the entirety of art (except maybe for his wife, Christine). He introduced me to art movements and artists that I would have never come across on my own, and, for that, among many other things, I owe him an eternal debt. I will do as much as I can in the future to pay back on that debt and to honor the man.

Seeing the inanimate corpse of your best friend is a terrible thing for a human to endure. If only the world we spent so much time creating, even for one day, could actually exist, what a glorious undead fiend he would make.

CHRIS SEAMAN

CHRIS SEAMAN was born in 1977 in Canton, Ohio. He graduated summa cum laude in 2000 from Columbus College of Art and Design with a B.F.A. in illustration. His work can be seen in numerous children's books and collectible card games. His first freelance job was with Wizards of the Coast on the *Harry Potter Trading Card Game* in 2001. Chris has also worked on such card games as *Legend of the Five Rings* and *World of Warcraft*. His fantasy illustrations have been judged by his peers and exhibited by the Society of Illustrators in New York City and the Los Angeles Society of Illustrators. Chris continues to perfect his style and live in his hometown of Canton with his wife, Melinda, and their shih tzu pup, Contessa-Louise-Fitzgerald-Seaman. Visit Chris at his website www.chrisseamanart.com.

ACKNOWLEDGMENTS

There are many people I would like to thank during the journey of creating this book, but a special thanks goes to my wife, Melinda: without her loving support and sacrifice, I would be nothing. I would like to thank my brothers Dan and Matt: thanks for the coffee! My family and friends for understanding and supporting my artistic talents. And, of course, how could I forget Chuck, Jim and Thomas . . . your inspiration was and is priceless. Thank you for letting me glimpse into your artistic visions!

DEDICATION

I would like to dedicate this book to my parents, Mike and Rhonda, for their constant encouragement and guidance through the years, and for sending me off into the world with passion and drive.

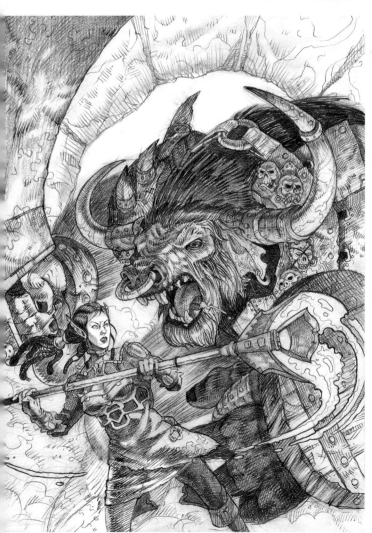

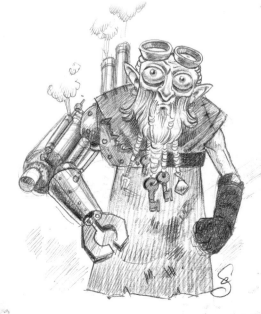

THOMAS MANNING

THOMAS MANNING was always fascinated with images, making them and using them to communicate and express ideas. After graduating from college in 1991, he began to pursue showing art in galleries. A fan of fantasy books, movies, games and art, he spent a year teaching himself to paint in a more naturalistic manner, building a portfolio of fantasy paintings. In 1997, he was contacted by TSR, the makers of *Dungeons & Dragons*, which lead to his first professional illustration job. Since then, Thomas went on to work for a client list that includes Time Inc., Roc/Penguin Books, Wizards of the Coast, Upper Deck and White Wolf.

Other than painting and drawing, the things that helped make Thomas the artist that he became include: books of many kinds, coffee, hard-core punk and Tom Waits, looking at art wherever he found it, movies, traveling with no real destination, playing games, riding his bicycle, working around the house and garden, the environment and daydreaming about one day living in Paris. He passed away suddenly in 2007.

DEDICATION

A special dedication and thanks to Steven W. You did more to influence me and put me on this path I have chosen to travel than you know. Thanks for being such an amazing person and friend.

ACKNOWLEDGMENTS

- Chris, Chuck, Jim, and to Mary and everyone else at IMPACT Books who made *Wreaking Havoc* such a wonderful experience.

- Jim P., Tony M., Prof, and Adam C., all of whom as artists and friends have pushed me to be better than I thought possible.

- Tony O., Mark H., Pensacola Bob and the other O.P.O.P.s for coming back into my world, for the great times and support—it feels like the 1980s all over again.

- The members of the game group who have fueled and inspired so many of my twisted images with the worlds you have created over the years.

- The family. Not only the wonderful one into which I was born, but the one I was lucky enough to have married into, who have supported me through all of the highs and lows of this art ride. Especially my brother Dan, who has been more than just a good brother, but a great friend.

- And, of course, listed last, though she is always first, my wife Christine, the moon in a bucket, without whom this journey absolutely would not be possible, or anywhere near as fulfilling.

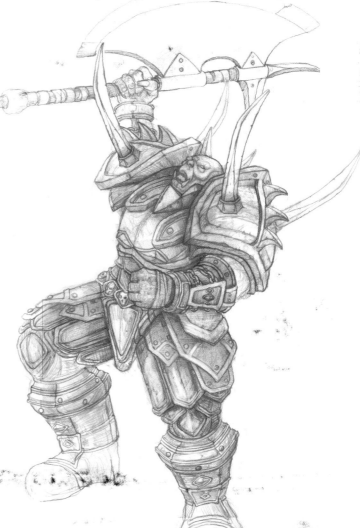

TABLE OF CONTENTS

THOMAS MANNING
THE TRUE FAE

INTRODUCTION

It's thought by some that designing things that never existed might be the easiest task in the world: after all, if it never existed, who's to prove what one made up was "wrong"? Anyone who has tried the above knows just how misguided that belief is, especially when the image created is supposed to convince other viewers of its reality.

In the art and science of designing fantasy, the greatest single tool is our own reality, our "mundane," day-to-day world. It is in contrast to our world that fantasy gets its breath of life. If the artist can convince the viewer that the world as represented in his art is real, then any element within that composition will feel "real" by association. If it *looks* real, by dint of unequivocal detail, it has a fine chance of being believed, or at least accepted.

One way to imply reality is to construct the fantastic in the guise and garb of a comfortable object: In *The Sorcerer's Apprentice* it is the broom coming alive that bridges the gap between what might be truly real and what must be fantasy. Once the viewer buys into the reality of a walking broom, the rest of the magic in the story is perfectly acceptable.

Leaving brooms and enchanted pumpkins to the side, the characters that lie ahead in the pages of this book are monstrous monsters and unlikely abominations imbued with cruel, tusked animosity and fanged intention. When an artist approaches this type of fantasy, his talent and imagination is best served by a thorough understanding of line, color, lighting and composition.

Throughout the pages of the book are myriad imaginings made flesh through the vision and talent of these four artists. It's a hard-won gift to render believable not only that which never was, but to do so on the completely flat page. If magic abides, here are four magicians. Their one shared power: to wake in our minds a surety that the remarkable things we see within have always existed.

–MICHAEL WM. KALUTA
NEW YORK CITY, SEPTEMBER 2007

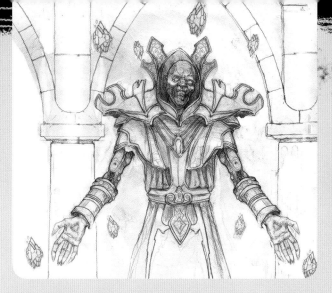

THOMAS MANNING (1966–2007)

Shortly after completing his work on *Wreaking Havoc*, Thomas Manning died quite unexpectedly. This collaborative project, which includes Thomas's most recent work, is dedicated to his memory.

"Any magazine-cover hack can splash paint around wildly and call it a nightmare or a Witches' Sabbath or a portrait of the devil, but only a great painter can make such a thing really scare or ring true. That's because only a real artist knows the actual anatomy of the terrible or the physiology of fear—the exact sort of lines and proportions that connect up with latent instincts or hereditary memories of fright, and the proper color contrasts and lighting effects to stir the dormant sense of strangeness. … There's something those fellows catch—beyond life—that they're able to make us catch for a second. Doré had it. Sime had it. Angarola of Chicago has it. And Pickman had it as no man ever had it before or—I hope to Heaven—ever will again."

—H.P. LOVECRAFT, *PICKMAN'S MODEL*, 1926

Thomas Manning had it too. On our frequent trips to the local bookstore/café to work on drawings for various assignments, I would often look over at what he was working on and be struck with an intense pang of envy. "Dammit, Manning. Why didn't I think of that?" I would say to myself. But the envy would be pushed out immediately by that sense of glee that I enjoyed as a young boy looking at the works of Parkinson or Frazetta. This sense of glee can really only be summed up as reveling in the presence of something that is truly cool.

It's a terrible realization that there is now going to be less cool stuff in the world. I am truly saddened by it.

—JIM PAVELEC

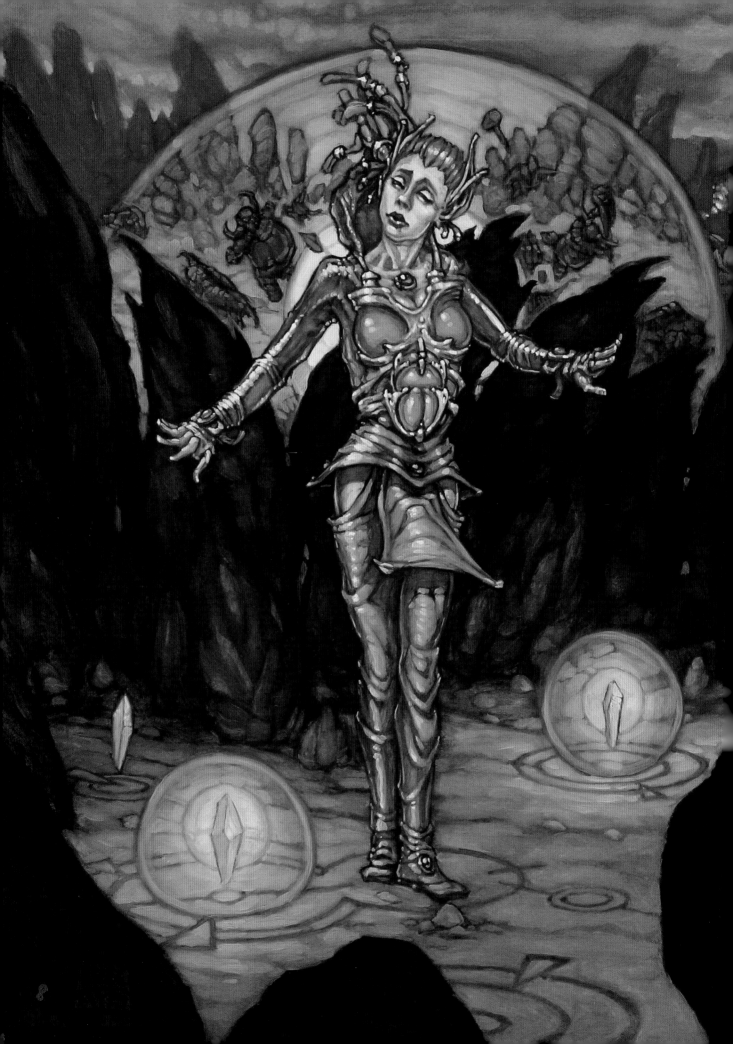

CHAPTER 1
THE BASICS

Every journey has its beginning, and every adventurer must study the path before he rolls the dice. Step inside and we will show you some basic steps that will help you along your journey. With skill and some serendipity, you will soon be sketching and painting fantastical tales of weapons and war.

"Cry 'Havoc,' and let slip the dogs of war;
That this foul deed shall smell above the earth
With carrion men, groaning for burial."

—WILLIAM SHAKESPEARE
***JULIUS CAESAR*, 1599**

METHODS

Part of being an artist is experimentation. Like scientists, we experiment with new theories, new dynamics, new interpretations of old ideas, new solutions to old problems, new inspiration for technological change and new techniques and materials. Try different kinds of materials and methods; the ones that work the best will find you.

Art materials and methods are as varied and diverse as the artists who use them. Most artists have multiple methods that constantly evolve as they learn, grow and discover new things. Change is an excellent means of sparking creativity.

Here are some of the basic steps for creating fantasy warriors, from the initial sketches to final painting. You may or may not go through each and every step when you create your own art. It's different for each artist. In the art timelines below and on the following page you can see the differences between our creative processes.

Chuck's Drawing Supplies

DRAWING

Start by roughing out your ideas in a hardbound sketchbook. It's good to work on thumbnails first. This way you can work small and quickly, without thinking too much. Once you find a preliminary sketch that you want to explore further, either enlarge it in your sketchbook, or, if it already has enough detail, start a larger drawing on your paper of choice. Remember that hot-pressed paper is smoother while cold-pressed paper has more tooth.

EDITING

Once you've finished a drawing you like, there are various ways you can edit it before proceeding with the painting process. One of the most common ways to edit a drawing is with image editing software. Scan your drawing and then clean it up or make adjustments. Then you can print out a clean version of your drawing on the

paper of your choice. You may want to use white paper, or try using toned paper to set the mood for the painting and eliminate all of the white immediately.

If you don't have a scanner or editing software, or, if your drawing doesn't require adjustments, you can simply take your drawing to a copy shop. You can shrink or enlarge the drawing, depending on what the painting calls for. Before scanning or copying, you may want to fix your drawing with a fixative such as Krylon Workable Fixatif. This will help you avoid smudges and smears.

PAINTING PREPARATION

There are several ways to transfer the drawing to your painting surface. One of the more common methods is to use a matte medium. First spray fixative on the image, then adhere the paper to a panel of Masonite or illustration board with matte medium, using a brayer to roll out the bubbles. To ensure a flat surface, clamp the panel in between two thick pieces of wood. Let it dry overnight.

Graphite transferring is another method for transfer-

JIM'S METHOD TIMELINE

1 Thumbnails	2 Rough sketch to fill out composition	3 Finished drawing	4 Scan and print finished drawing	5 Spray fix drawing	6 Adhere to Masonite with acrylic gloss medium	7 Bray to flatten out air bubbles	8 Cover drawing with acrylic medium	9 Paint

CHRIS'S METHOD TIMELINE

1 Three to five thumbnails	2 Finished drawing	3 Copy (enlarge or reduce)	4 Graphite transfer on gessoed board	5 Fix graphite transfer with Krylon Fixatif	6 Block in earth tones with acrylic wash	7 Block in with oil paint	8 Begin details	9 Add more and tighter details	10 Fix painting with spray varnish or Fixatif after drying

ring your drawing onto your painting surface. Using a 7B graphite stick, rub graphite all over the back of the copy of your drawing, completely covering the surface. Use a paper towel to rub the graphite into the tooth of the copy paper. Place the drawing on your painting surface. Then, using a sharp HB pencil, trace over the lines of the drawing, and the graphite on the back of the copy paper transfers to the painting surface. Then fix the transfer.

You can also use graphite transfer paper (which is similar to carbon paper) instead of applying graphite to the back of your drawing. Simply place a piece of transfer paper between your drawing and the painting surface and proceed to trace the lines.

Finish preparing your painting surface by coating it with gel medium or clear acrylic gesso. If you prefer to use white gesso, apply it *before* completing a graphite trans-fer (otherwise it would cover up a drawing or transfer). For a smoother surface, dilute the acrylic medium with water, or let the medium or gesso dry for an entire day and sand it with sandpaper such as 3M 220 fine grit. Gesso provides a somewhat rougher surface if you prefer more tooth.

PAINTING

Applying paint is an exciting experience and a process that varies greatly from artist to artist. Many artists start by applying a wash (or washes) to the entire surface. You can use acrylic or oil paints for this process. Acrylics dry faster than oil paint. Try adding texture by applying turpentine with a sea sponge, a toothbrush or another texturing tool to add marks before this layer dries.

Oil paint comes in numerous grades and brands, and you usually get what you pay for. Try a variety of brands. You can even make your own paint from dry pigments.

To thin oil paint for glazing and detail work, use a medium such as Liquitex's Liquin or linseed oil. Liquin

Chris's Painting Supplies

is especially good for detailed areas (it helps speed the drying time and can be used as a final varnish). Try using two parts oil paint, one part linseed oil or Liquin and a touch of turpentine.

Brushes come in a variety of shapes, sizes and brands. Experiment to find out what you like. You can also use a variety of miscellaneous objects to create random textures and smudges, including your finger; the end of a brush; a big crusty, hardened brush; a palette knife; a sponge; paper towels and a toothbrush. Get creative with your tools.

To clean your brushes and painting tools, try Turpe-noid. It is an odorless turpentine substitute.

Even with modern printing techniques, there is simply no real substitute for the particular way light plays through an oil painting. Painting in oils is messy, and it takes ten times as long as any other traditional or computer-based painting technique, but there's a reason why this technique is used for illustration even today. Layers of transparent color and clear medium capture light and glow just like a stained glass window.

THOMAS'S METHOD TIMELINE

1	2	3	4	5	6	7	8	9	10
Gesture drawings	Enlarged sketch	Finished drawing	Scan then adjust and resize in Photoshop®	Print on smooth bristol board	Adhere to Masonite	Bray to flatten out air bubbles and dry between wooden boards	Cover surface with gel medium or gesso	Apply oil wash	Paint

CHUCK'S METHOD TIMELINE

1	2	3	4	5	6	7	8	9	10
Thumbnail (or a tight sketch if a good photo reference is available)	Detailed sketch	Scan then adjust and resize in Photoshop®	Print	Transfer to painting surface with graphite transfer paper	Cover surface with clear acrylic matte medium	Apply acrylic wash (or oil wash, if there's enough time)	Block in color groups with transparent oil washes	Apply opaque color, wet-in-wet	Corrections and final details

MATERIALS

Whether you're drawing or painting, a variety of art supplies are at your disposal to create whatever you can dream. Artists use a variety of tools, from a simple brush to a dinner fork. Experiment and find out what works for you. Remember, you are in control of what you are creating. Your tools do not control you!

THOMAS'S MATERIALS

DRAWING SUPPLIES
Smooth bristol 100-lb. (220gsm) paper, 9" × 12" (23cm × 30cm) hardcover spiral-bound sketchbook, Strathmore drawing paper, Sanford Design Drawing 3800 pencils (B, 2B, 4B, 8B, HB), Derwent Sketching pencil (medium wash 4B), Staedtler Mars plastic eraser, Sanford Tuff Stuff Eraser Stick, Holbein white gouache, hair dryer, spray bottle

PAINTING SUPPLIES
Masonite, medium-weight drawing paper, gesso, gel medium, synthetic and sable brushes in various shapes and sizes, Maroger medium (homemade), Liquin, Turpenoid, Medium hollandaise Dutch Medium (homemade), airbrush medium, gloss medium varnish, toothbrush, brayer, hair dryer, spray bottle, sea sponges

PIGMENTS
Alizarin Crimson, Burnt Sienna, Burnt Umber, Cadmium Yellow, Cerulean Blue, Chromium Oxide Green, Cobalt Blue, Cobalt Violet Deep, Compose Blue, Indian Red, Ivory Black, Manganese Blue, Mars Red, Naples Yellow Italian, Neutral Gray, Olive Green, Payne's Gray, Provence Violet, Prussian Blue, Prussian Green, Raw Sienna, Raw Umber, Titanium White, Van Dyke Brown, Vermilion, Yellow Ochre

CHRIS'S MATERIALS

DRAWING SUPPLIES
Derwent HB graphic pencils, Design kneaded eraser, 7B graphite stick, hardbound sketchbook, hot-pressed bristol board, compass, ruler, T-square, carpenter's L, drawing triangle

PAINTING SUPPLIES
Higgins Fadeproof Inks, Liquitex Acrylic Gesso Surface Prep, Liquitex acrylic paint, Liquitex Gloss Medium & Varnish, Liquitex Matte Medium, Winsor & Newton University Series Watercolor round brushes 6 to 000, big chunky brush, a variety of old brushes, extra chunky brush, palette knife, sponge, paper towel, finger, toothbrush, 300 cold-pressed Crescent illustration board, Best Klean odorless turpentine substitute, Winsor & Newton linseed oil, Winsor & Newton Liquin, masking tape, 3M 220 fine grit sandpaper, Krylon Workable Fixatif

PIGMENTS
Alizarin Crimson, Burnt Sienna, Burnt Umber, Cadmium Red, Cadmium Yellow, Cadmium Yellow Light, Cerulean Blue, Cobalt Blue, Dioxazine Purple, Mars Black, Phthalo Blue, Raw Umber, Sap Green, Titanium White, Venetian Red, Viridian Green, Yellow Ochre

CHUCK'S MATERIALS

DRAWING SUPPLIES
Bienfang Graphics 360 marker paper, Tombow Mono B series pencils (the Jaguar of pencils), Faber-Castell pencil-shaped erasers, Union gray/white eraser, Berol Rapidesign circle and combination ellipse templates, French curve

PAINTING SUPPLIES
Crescent 110 illustration board, hog hair bristle brushes (various sizes), red sable rounds and flats (various sizes), Nos. 5, 3 and 1 sable round, Liquitex acrylic matte medium, Liquin oil medium, Weber Rapidry alkyd drying medium

PIGMENTS
Alizarin Crimson, Burnt Sienna, Burnt Umber, Cadmium Red Deep, Cadmium Yellow Deep, Flesh Tint, Lemon Yellow Hue, Magenta, Manganese Blue, Naples Yellow Hue, Phthalo Blue, Titanium White, Ultramarine Blue, Winsor & Newton Transparent Yellow, Yellow Green, Yellow Ochre

JIM'S MATERIALS

DRAWING SUPPLIES
Sanford wood-cased graphite pencils (5B–2H), Pilot black ballpoint pen, Pentel .5mm mechanical pencil, kneaded eraser, ruler, compass, mechanical plastic eraser, 1½-inch (38mm) brush for clearing eraser crumbs, hardbound sketchbook, Borden & Riley Bleedproof Paper

PAINTING SUPPLIES
Dr. Ph. Martin's concentrated watercolors; inks: Daler-Rowney, Holbein; acrylic paints: Liquitex, Golden, Holbein; oil paints: Holbein, Winsor & Newton, Gamblin, Old Holland, Daler-Rowney Georgian; brushes: coarse hog's hair, synthetic nylon; sable: various brands, sizes and shapes; palette knives: various styles; medium: Winsor & Newton Liquin; paint thinner; ⅛" (3mm) Masonite; assorted papers; Liquitex Gloss Medium & Varnish; Liquitex Matte Gel Medium; brayer

PIGMENTS
Alizarin Crimson, Burnt Sienna, Burnt Umber, Cadmium Lemon, Cadmium Orange Light, Cadmium Red Deep, Cadmium Red Light, Cadmium Yellow, Cerulean Blue, Chromium Oxide Green, Cobalt Blue Hue, Flesh Tint, French Ultramarine Blue, Green Gold, Indian Red, Indigo Blue, Ivory Black, Monochrome Tint (cool), Monochrome Tint (warm), Naples Yellow Light, Olive Green, Phthalo Green, Radiant Green, Raw Sienna, Raw Umber, Sap Green, Titanium White, Turquoise Blue, Yellow Ochre

BASIC SHAPES

Everything that you see and, for the purposes of this book, everything that you imagine, can be simplified into geometric shapes. These shapes can be an indispensable tool for sparking the creative process and making strong designs.

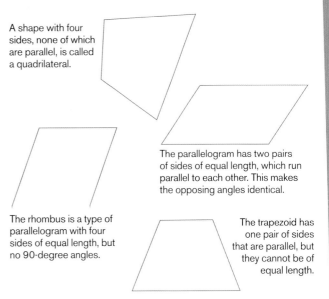

A shape with four sides, none of which are parallel, is called a quadrilateral.

The parallelogram has two pairs of sides of equal length, which run parallel to each other. This makes the opposing angles identical.

The rhombus is a type of parallelogram with four sides of equal length, but no 90-degree angles.

The trapezoid has one pair of sides that are parallel, but they cannot be of equal length.

Start Simply

Use basic shapes first, and then add more complexity and detail. Look at this axe—it is, at its core, a compilation of basic shapes—a triangle, two rectangles, a trapezoid and a quadrilateral. Using shapes such as the quadrilateral can help you wrap your brain around tricky perspective problems such as foreshortening.

Basic and Complex Shapes

The most basic shapes are the square, circle, rectangle and triangle. These four shapes are the foundation of good design. Lay these shapes over one another in a variety of ways to see what recognizable complex objects you begin to envision.

Any shape with three or more sides is called a polygon. A polygon's sides can vary in length and connect with each other at various angles. So, in fact, the basic shapes of the square, rectangle and triangle fall under the category of polygons, but polygons can be much more complex.

Polygons in Action

Here you can see how polygons can help you draw more complex shapes. The intricate form of this terrifying oni seems overwhelmingly complex at first. However, on closer inspection you can see that it's basically a triangle, two quadrilaterals and a trapezoid melded together. The dynamism created by the sharp angles of the shapes makes for a strong, active design.

LIGHT AND SHADOW

Light and shadow go hand in hand and can be broken down into a simple, six-step gray scale. Once you know these steps, you'll be able to render and give form to anything. Light sources are very important as well since they determine where shadows should fall. Mastering light and shadow will help you achieve a finished fantasy illustration look. When all the elements of the six-step gray scale are working together, you get a piece of art that pops off the page!

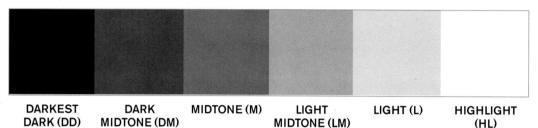

| DARKEST DARK (DD) | DARK MIDTONE (DM) | MIDTONE (M) | LIGHT MIDTONE (LM) | LIGHT (L) | HIGHLIGHT (HL) |

Six-Step Gray Scale
Here I've broken shading down into six steps from darkest dark to highlight.

Shading Shapes

Here you can see the six-step gray scale in use with a light source coming from the top right. Notice the order in which the different parts of the gray scale appear: M, DD, DM, M, LM, L, HL, LM. This order of rendering comes from the Renaissance period in art. It's called *chiaroscuro*. It gives the illusion of form and roundness that makes things pop!

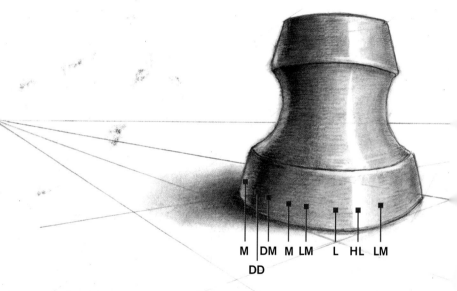

M | DM | M | LM | L | HL | LM
DD

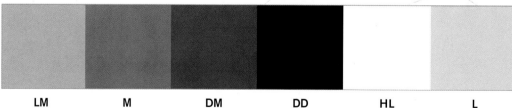

| LM | M | DM | DD | HL | L |

Six-Step Metal Gray Scale
The darkest dark and the highlight are right next to each other. It's the contrast between the two when used next to each other that makes the object look shiny.

Shading Metal

Let's mess with the order of the gray scale a bit. Here I want my object to look like shiny metal with a light source coming from the front of the object. This time the shading breaks down in this order: L, LM, M, DM, DD, HL, L, LM.

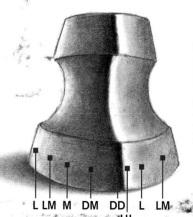

L LM M DM DD L LM
HL

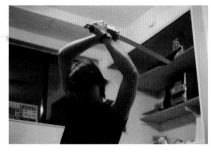

Contrast in Action

Here is an "awesome" picture of me wielding a deadly T-square! I'm an artist on a rampage. If you squint your eyes you can begin to see the contrasting elements already.

Contrast Breakdown

I've broken down the photo into black-and-white high contrast with no rendering. This separates the background elements from the foreground elements. Now the figure pops!

Reversed Contrast

I reversed the contrasting elements so everything that was white is now black and vice versa. This helps you see what the composition looks like with a dark background. It also helps you determine the shapes of the foreground elements.

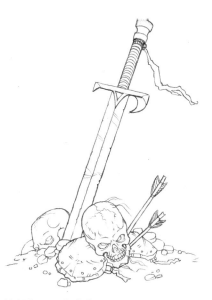

Lighting From Above

Here are the same objects, now fully rendered and with a clear light source. You can see all six steps of the gray scale come into play in the shadows. A shadow's darkest part is closest to the object casting the shadow. Notice how the shadow is darker right underneath the skull and armor.

Light Sources in Action

Here is a line drawing of a sword whose owner was clearly the loser on the battlefield. The shaded object that I constructed on the previous page made a good pommel shape for this sword.

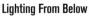

Lighting From Below

Now the light source is coming from the bottom, creating a creepier effect (think about the effect that holding a flashlight under your chin while telling ghost stories has on your listeners). The mood here is much more dramatic.

TIPS

- Draw from life. Set up some cool objects with a lamp over them. It's the best way to learn.

- Pay attention to the way light plays on objects you see at school, home or the library.

- While you're working, squint your eyes at your drawing to observe contrast.

- Draw with your eyes. Observation is key to light and shadow.

Gesture sketches contain the basic lines that capture the energy of the subject—a few swift, unlabored lines that convey the subject's character or motion. It has as much to do with the subject or model and the artist as it does with the marks on the paper. This is true whether you are drawing a figure from life or from a photograph, or a creature from your imagination.

You can see the gesture sketch's presence in a finished drawing or painting, and, more importantly, you can see its absence. Gesture sketching does not apply to drawing the figure alone; it is just as present in all other subjects, from landscapes (both real and imaginary) to an apple sitting on a table. A gesture sketch not only helps with proportion, scale and placement, but the mood of the art itself.

When practiced and used, gesture sketching will become second nature to you as an artist. It will become the core of not just the way you make art but, maybe more importantly, the way you see.

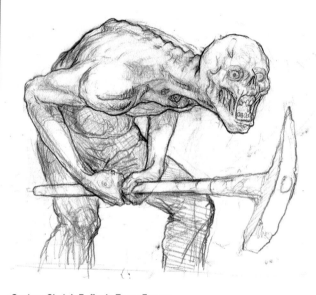

Gesture Sketch Reflects Tense Energy
In the gesture sketch of this fiend in action, the tense energy is apparent in the pose and the muscles, flexed and ready to attack. The mood is tense and energetic. See how the marks seem to move through the drawing in a rapid, almost aggressive manner?

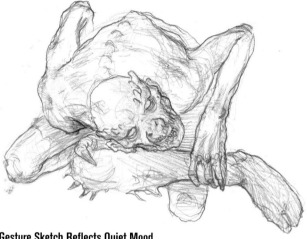

Gesture Sketch Reflects Quiet Mood
The pose of the sitting figure is quiet and relaxed, the body close in on itself, conveying a tranquil mood. Making the gesture sketch slower and less frantic reflects this quiet mood. The marks here are slower and more deliberate, mirroring the feeling of the subject, the artist and the viewer.

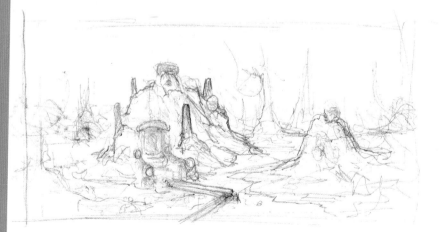

Gesture Sketch Establishes Mood
Using a gesture sketch to start a drawing or painting of a broader, larger subject or scene helps to establish the mood of that scene. Take a look at this landscape. What mood does the drawing evoke? Why does it evoke that mood and feeling?

TEXTURE

Understanding texture involves understanding flat pattern, and how that flat pattern wraps around a three-dimensional object. Learning to create texture can be an elusive skill. I tend to think of it as picking up a new trick or a new combination of old tricks. Ultimately, it's the way to add an infinite amount of detail to any surface and can make or break any piece of art. Here you can learn how to wrap both bumpy skin and fur around a simple sphere. I will also show you the power of metamorphosis by transitioning from one texture to another.

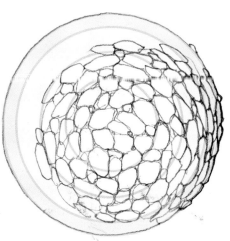

Basic Texture Technique: Bumpy Skin

Wrapping a simple texture around a ball is easy once you understand how the texture changes as it goes around. Start by drawing some concentric circles to indicate the different depths of the sphere. Fill in the center circle with some random cobblestone-like bumps. Notice how the bumpy skin texture in the center circle closest to you is almost flat. Continue filling in the next two areas with bumps, making them gradually thinner as they get closer to the outer edge. At the edge, the cobblestones should be very thin. Then, darken the gaps in between each stone, add shading and finish up your outline.

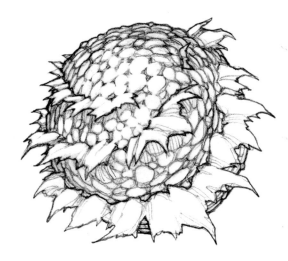

Texture Variation: Rings of Fur

Now that we know how to wrap bumpy skin around a sphere, we can add another texture to the mix. Draw a spiral line wrapping the sphere from top to bottom, and add clumps of ragged white fur along that line. Notice that even though the fur is growing in a spiral from bottom to top, it still gets thinner and shorter as it trails off around the edge. The addition of the fur rings will cause new shadows to emerge as well.

Texture Transformation: Furry

Now all the fur has grown in and we see a whole new texture around our sphere. Fur is best defined by its shadows more than anything else. Each clump should jut out from the very center of the circle, and the shadow will define the shape of each clump. This little guy's white fur is shorter on top and thicker at the bottom, so you will have small shadows on top, and bigger shadows at the bottom.

SCALE

The bigger they are the harder they fall. Here are a few of our characters to demonstrate the importance of size when creating your battle scenes. Notice the size difference between the gnome (smallest) and the Minotaur (largest). Now picture them as the same size in your head. Not that impressed? In fantasy illustration, the size of your characters plays a key role in the drama of your battle scene. Imagine a dragon that's the size of a mouse … kind of wimpy, huh? What's it gonna do, light a candle? But then imagine a dragon the size of your school—run away! An entire city block has been destroyed! That is a bit more terrifying. Notice how the four of us use scale in our battle scenes to create a more dramatic composition.

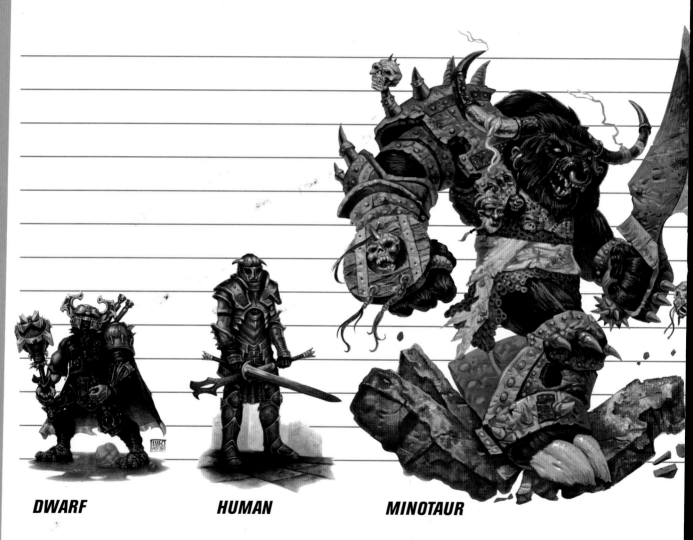

DWARF　　　　**HUMAN**　　　　**MINOTAUR**

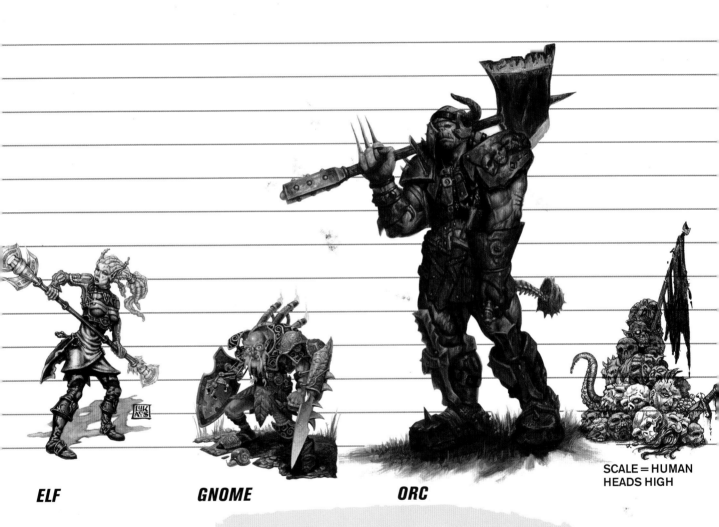

ELF

GNOME

ORC

SCALE = HUMAN
HEADS HIGH

COMING UP NEXT: DRAWING VS. PAINTING

In the next three chapters you'll find lots of step-by-step instruction on both drawing and painting. We'll teach you how to draw all of the weapons individually, and we'll explain how to draw or paint each character. Drawing and painting are equally important skills for fantasy artists and illustrators. If there's a drawing demo that you'd rather paint, choose colors that you like and use your newfound painting knowledge to complete the character. To create the drawing for one of the painting demonstrations, copy the basic lines that you see in the first step of the demonstration. Use your new skills to create warriors and weapons just the way you want them!

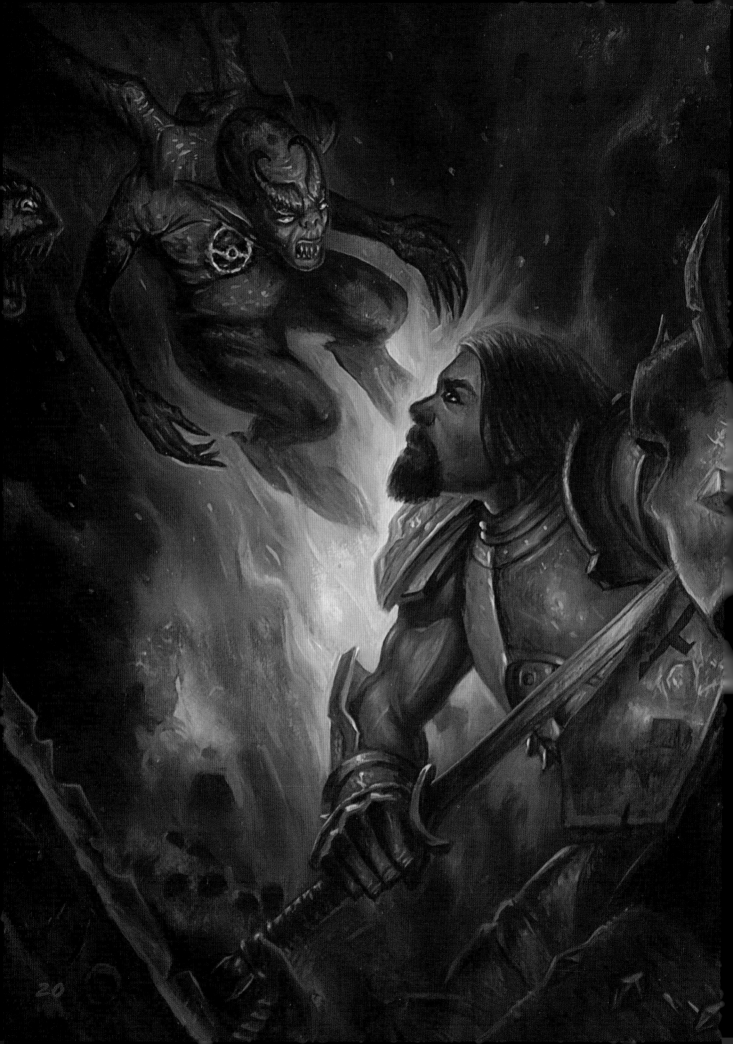

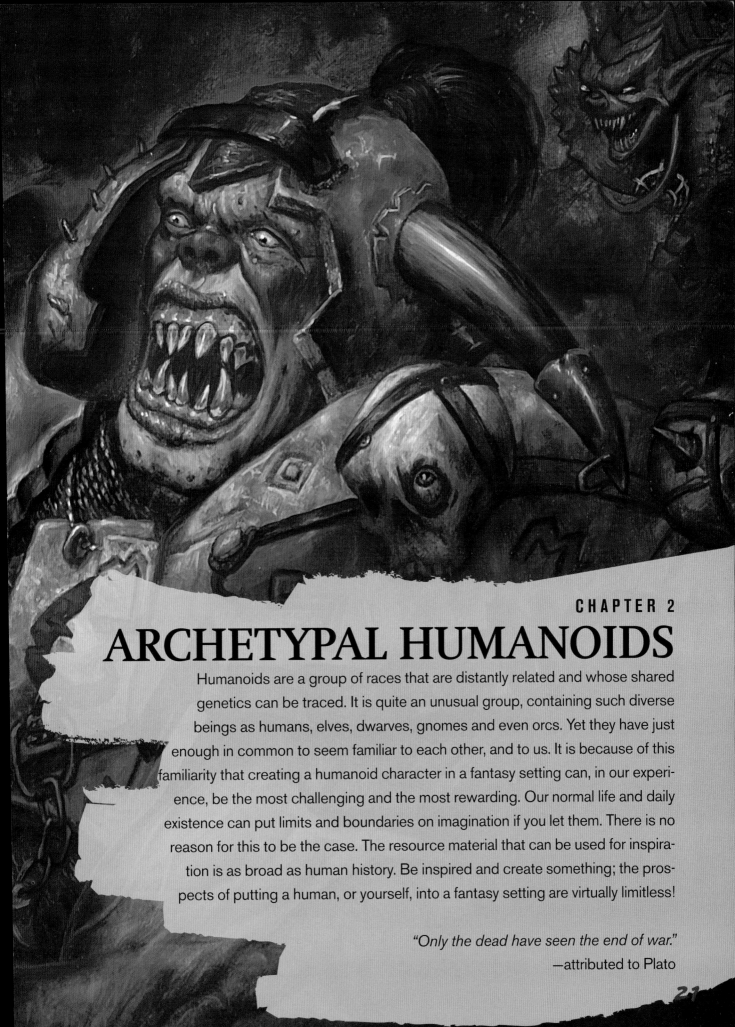

ARCHETYPAL HUMANOIDS

Humanoids are a group of races that are distantly related and whose shared genetics can be traced. It is quite an unusual group, containing such diverse beings as humans, elves, dwarves, gnomes and even orcs. Yet they have just enough in common to seem familiar to each other, and to us. It is because of this familiarity that creating a humanoid character in a fantasy setting can, in our experience, be the most challenging and the most rewarding. Our normal life and daily existence can put limits and boundaries on imagination if you let them. There is no reason for this to be the case. The resource material that can be used for inspiration is as broad as human history. Be inspired and create something; the prospects of putting a human, or yourself, into a fantasy setting are virtually limitless!

"Only the dead have seen the end of war."
—attributed to Plato

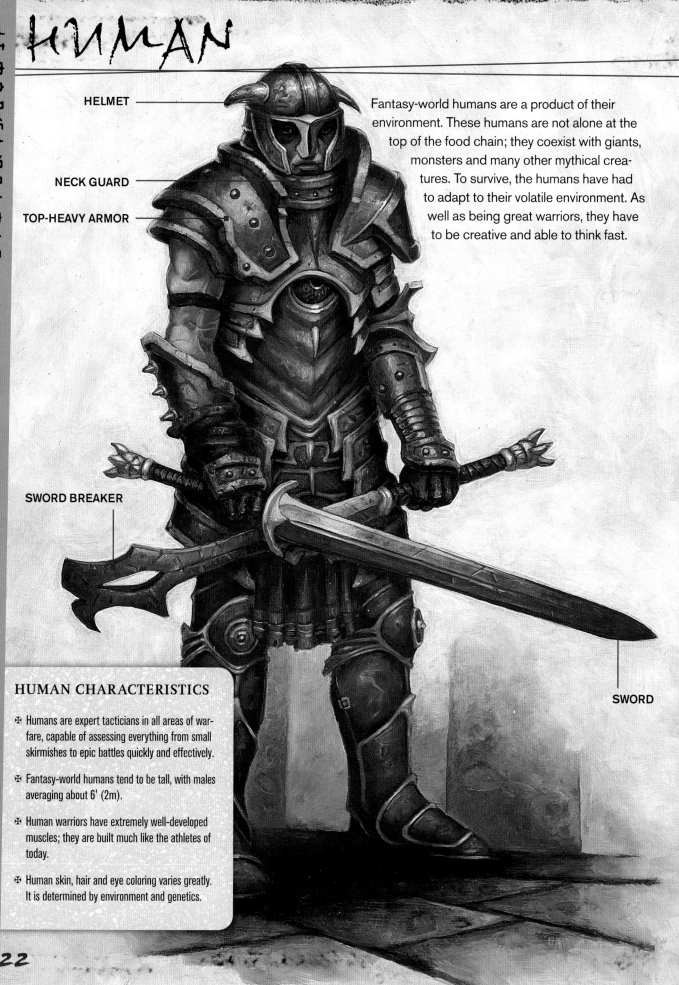

HUMAN

HELMET

NECK GUARD

TOP-HEAVY ARMOR

SWORD BREAKER

SWORD

Fantasy-world humans are a product of their environment. These humans are not alone at the top of the food chain; they coexist with giants, monsters and many other mythical creatures. To survive, the humans have had to adapt to their volatile environment. As well as being great warriors, they have to be creative and able to think fast.

HUMAN CHARACTERISTICS

✠ Humans are expert tacticians in all areas of warfare, capable of assessing everything from small skirmishes to epic battles quickly and effectively.

✠ Fantasy-world humans tend to be tall, with males averaging about 6' (2m).

✠ Human warriors have extremely well-developed muscles; they are built much like the athletes of today.

✠ Human skin, hair and eye coloring varies greatly. It is determined by environment and genetics.

ARMOR

1 When designing armor, it's important to think about the type of opponents the fighter may engage. This armor is going to be top heavy because humans fight a lot of huge foes. It'll be especially bulky around the upper arms, shoulders and neck. Use a gesture sketch to start drawing the basic forms of the torso. Map out the position of the neck and arms.

2 Start to define the different shapes and components that make up the armor. Give the neck guard a more definite shape. Then add the lines for the pieces that protect the front of the torso and rib cage.

3 Form the shoulder armor out of separate moving parts to give the fighter more mobility. The left arm requires less mobility, so it has more armor layers to give him better defense against his opponents. Use a kneaded eraser to remove extra marks and lines.

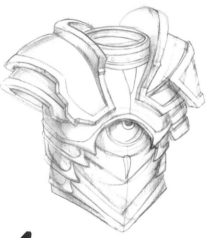
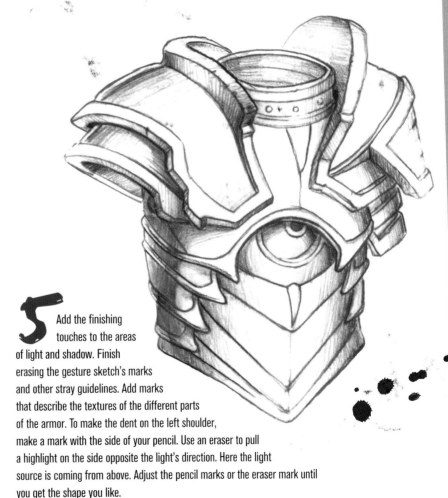

4 Finish defining all of the components of the armor. Use light and shadow to give the armor shape and definition. You can see how the shadows help define the curved shapes on the side where it begins to move back into space. Notice the areas where overlapping pieces form cast shadows, particularly on the right side.

5 Add the finishing touches to the areas of light and shadow. Finish erasing the gesture sketch's marks and other stray guidelines. Add marks that describe the textures of the different parts of the armor. To make the dent on the left shoulder, make a mark with the side of your pencil. Use an eraser to pull a highlight on the side opposite the light's direction. Here the light source is coming from above. Adjust the pencil marks or the eraser mark until you get the shape you like.

HELMET

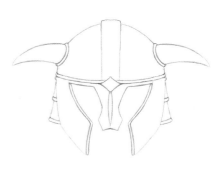

1 Think about how the helmet will fit and move with the armor, especially the neck guard. Use a ruler to make crosslike marks to find the center of the helmet. Then use a compass or another circle-making tool to find the crown of the helmet. Next, use the ruler to layout other marks to start defining where other parts of the helmet will go, and what shapes they will take.

2 Start to define the different shapes and components that make up the helmet. Use two overlapping triangles to create the basic shape of the nose guard over the nose. To make the neck guard look as if it is moving back into space, wrapping around the neck, draw curved lines that start lower toward the center of the drawing and end higher at the point farthest from the center. It's almost like connecting the dots. Add horns to the sides.

3 Finish drawing the shapes and forms. The narrow band above the eyes follows the same curve as the bottom of the neck guard. This curve helps define the perspective of the helmet. Then, erase all of the original guidelines and marks. Notice the lines that show the thickness and provide perspective to the cheek guards.

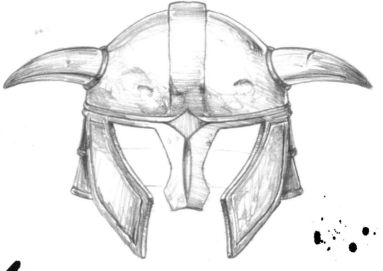

HUMAN WEAPONRY

- Humans create armor that is heavy for deflecting blows from creatures more than twice their size.

- The armor is made of many moving parts to allow for quick movement.

- Their highly specialized weapons are designed with precision and efficiency in mind.

4 Work on the light and shadow to give the helmet definition. You can refine the helmet further by concentrating on marks that describe the textures of the different parts of the helmet. Look at the difference between the horns and the crown of the helmet, for instance. The marks that define the horns are smoother and follow the form's curve, getting darker at the points. This gives them a more natural texture than the more roughly textured metal surface.

SWORD

1 The first step in the drawing looks a bit like a cross. Map out the measurements for the blade, hilt and location of the guard. Use a ruler and a compass or another circle-making tool such as a stencil or template. A square is helpful for making sure your crosslike mark is at a 45-degree angle.

2 Refine the tip of the sword and the sharpened edges of the blade by creating a second set of lines that are just to the inside of the edge of the blade. Keep these the same space apart all of the way around. Add the lines for the fuller (the indention that runs down the center of the blade). Using your compass, lay out the shape and designs of the hilt. Use the center-line of the sword and the point where the cross line meets to put the point of the compass. Decide on the first shape and make it. Then, using the compass, make another mark that follows the same curve just inside of the first mark.

3 Refine the shapes and designs in the sword. Add the lines for the wrapping of the handle, and finalize the shape of the guard and pommel. Use the curve of the hilt as the guide for finishing these elements. This will add to the illusion that it is a round object. Erase some of the guides and other stray marks.

4 Start depicting light and shadow. The light source is above the sword, so shapes that move back into space like the sword's edge or the bottom side of the fuller will be light, while the bottom edge of the sword and the top edge of the fuller will be in shadow. This is what really gives the sword shape and definition. Watch that light source!

5 Add the finishing touches to the areas of light and shadow to refine the form of the sword. Erase any straggling guidelines or marks. Focus on marks that describe the different textures of the sword. The metal of the sword's blade is different than the metal of the hilt. Use a smoother mark on the hilt to help separate and define it as opposed to a darker, harder and rougher mark for the blade. Add a few scratches and dings that have been picked up in battle!

SWORD BREAKER

1 A sword breaker is used both offensively and defensively. It can be used as a shield or to disarm an opponent. It is thick and clublike with no sharp edges.

While it's still important to be accurate in your lines and measurements, this weapon also has a more curved, organic shape. Start with a gesture sketch to get the overall sweep of the weapon.

2 Start to define the shapes that make up the sword breaker. Use a ruler and a compass. Map out the measurements for the weapon and shield end as well as the hilt and location of the guard. The sword breaker is about the same length as the sword, but it's much thicker and heavier so it can block blows of larger weapons. Think about the types of weapons it might be used to block and thus what kind of forms and hooks might be useful.

3 Begin refining the shapes and designs. Add the wrapping of the handle and finalize the shape of the guard and pommel. Many of these shapes are similar to those on the sword since they were crafted by the same weaponsmith. Make sure these marks all curve in the same direction to define the round shape and perspective of the pommel, grip and guard. Start to erase some of the guides and other stray marks (including a lot of the initial gesture sketch).

4 Start depicting light and shadow. The light source is above the sword breaker, so the lower half of the weapon end is in shadow and the upper half is in light. This helps define the shape of the blade, making it look as if the blade has a wedge shape. This is what really gives the sword breaker shape and definition. Think about the thickness of the sword breaker. It has to be sturdy to block bigger weapons.

5 Add the finishing touches to the areas of light and shadow. Erase stray guidelines and marks. Give the sword breaker character with marks that describe the different textures as well as the scratches and dings it picked up in combat.

DRAWING DEMONSTRATION

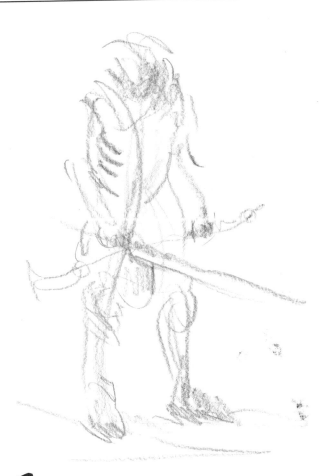

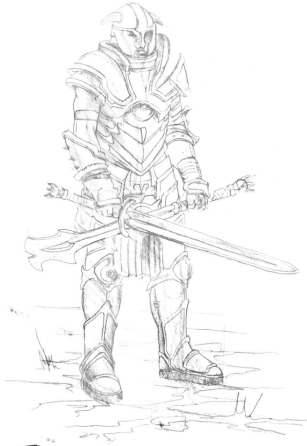

1 Start with a gesture sketch. Gesture sketches help you to maintain fluidity and freshness while creating a drawing with the right proportions and scale. Map out the locations of important parts like the legs, weapons, chest and head. Some of these features, such as the feet and the face area, will be in shadow. There's also a cast shadow on the ground.

2 Begin refining some of the bigger shapes and forms. Notice how similar the head and feet are to the original gesture sketch's marks in size and shape. Working from the initial sketch, find some of the sharper and more concrete lines that form the armor and body parts.

Now the shapes, parts and functions of the armor and weapons take on their final form. For the most part, these elements actually follow and mirror the body parts themselves. Start to erase some of the stray gesture sketch marks and guidelines.

RATHER PAINT INSTEAD?

Want to go beyond drawing your human warrior? Choose colors that you like and follow the basic painting directions on pages 10–11. Check out some of the other painting demonstrations. The same basic principles apply here; just the forms and colors are different.

EFFECTIVE ERASERS

The eraser is not just for fixing mistakes! It's a useful drawing tool. Use it to pull out lights in your drawings.

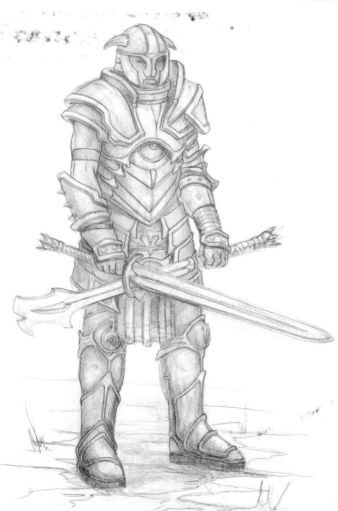

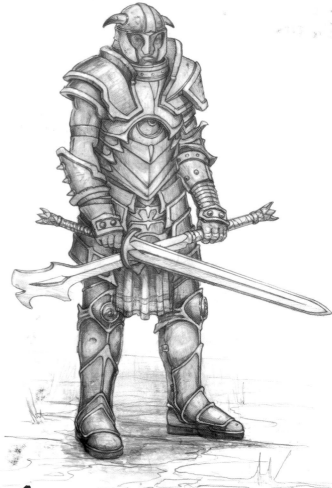

3 Finish defining all of the parts and components of the warrior's armor by sharpening their lines and edges. Remember, this armor is designed to give maximum protection while having many parts that move together to allow for speed and mobility. Pay attention to how the different parts might move and overlap. In the area around the rib cage each segment appears to go under the one above it, allowing the warrior to bend side to side.

4 Use shading to define the shapes and to show how they overlap. Use your eraser to pull out lights. The gesture sketch in step 1 began to establish the light source and shadows. While the marks have been tightened through the drawing process, the location of the shadowed areas from the gesture sketch remains the same. You may not see the gesture sketch at this stage, but you will still see its effect on the drawing through the placement of different parts like the weapons and the pose itself. Give the warrior more character by concentrating on marks that describe the textures of the different parts of the armor. Now you have a warrior ready to defend his realm.

TECHNIQUE

PULLING HIGHLIGHTS

After the drawing is done and I feel like there are no more pencil marks to be made, I use this technique to make the brightest highlights.

1 Keep your light source in mind as you determine the location of your brightest highlight.

2 Make a point on a kneaded eraser or use the sharp edge of a plastic eraser. Determine the size you want the highlight to be and use the eraser to "pull" it out.

3 Depending on how much graphite you've used, you may have to repeat step 2 several times, usually cleaning off the eraser each time. (I rub the eraser on my pants, but you should probably use a cloth or scrap of paper that has a rough texture.)

ORC

Orcs are characteristically dumb, brutish menaces. They are dirty, foul smelling and barbaric. However, I think orcs deserve a little more credit. Any group of beings that can function as a civilization cannot be completely ignorant. While not at the top of the intellectual ladder, orcs are reasonably intelligent. They are able to communicate with each other and they have developed a system of writing. Orcs are aggressive and will not tolerate incursions into their lands. They will initiate combat or even large-scale wars if they feel the potential gain is worth the risk. However, they do not charge blindly into battle for bloodlust's sake. Their warriors are proud and revered among their people. Female orcs can be as deadly as their male counterparts. The orcs'

HELMET

BATTLE-AXE

SKULL-AND-SPINE MORNING STAR

main weakness is that their military strategies are not very complex. If their opponents can withstand the initial charge, they may be able to achieve victory through superior tactics.

ORC CHARACTERISTICS

✠ Orcs average a height of 10' (3m), and a weight of 400 to 600 lbs. (181 to 272kg) without their armor.

✠ Orcs are well muscled and agile from hard lives forged in mountainous regions.

✠ Orcs are carnivorous and will eat the flesh of almost all creatures, including humans.

✠ Orcs usually choose to live at higher altitudes, and enjoy cooler weather.

HELMET

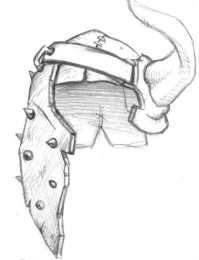

1 Draw a rounded cone shape for the skullcap. On the left side, draw a large trapezoidal slab of metal to protect the orc's face and neck. On the right side, draw a more intricately shaped piece of metal to cover the ear area. This piece should be held in place by a thick strap that runs diagonally across the skullcap. The ear cover is also the base for a large, curving ox horn.

2 Extend the back of the helmet and divide it into two pieces at the bottom. To give the metal pieces dimension, draw parallel lines along the front edge of each and connect them with short horizontal lines. You want the metal to look like it's about ½" (13mm) thick—sturdy enough to absorb attacks, but not so heavy that it would break the wearer's neck. Create metal loops to hold the parts together.

3 Make the front edge of the neck guard jagged and torn. Add randomly placed spikes to this part; use hatch marks to create indentations and gouges in the metal. Let's make the skullcap a thick leather to offset the weight of the metal parts. Add some stitching to it to lend to the overall piecemeal design.

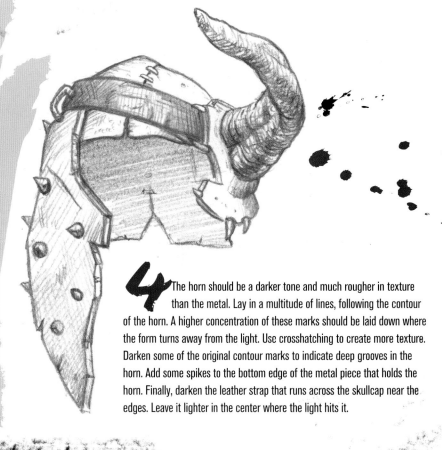

TIPS

- Do not make orc armor symmetrical or uniform.

- Draw the orc's head smaller in proportion than the typical human head-to-body ratio. This will make his size seem immense.

- Find some good bodybuilding magazines to use as reference for drawing the orc's massive limbs and trunk.

- An orc's facial expression should not be silly or dumb. They are a brave and proud race, and their face and posture should reflect this.

4 The horn should be a darker tone and much rougher in texture than the metal. Lay in a multitude of lines, following the contour of the horn. A higher concentration of these marks should be laid down where the form turns away from the light. Usc crosshatching to create more texture. Darken some of the original contour marks to indicate deep grooves in the horn. Add some spikes to the bottom edge of the metal piece that holds the horn. Finally, darken the leather strap that runs across the skullcap near the edges. Leave it lighter in the center where the light hits it.

AXE

1 Draw a long spherical shaft that is flat at one end and pointed at the other. The pointed end will protrude from the top of the axe head to give the axe additional offensive capability. The axe head is quite large. A slight angling and curvature of its lines should take it just past a rectangular shape.

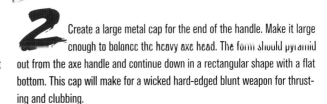

2 Create a large metal cap for the end of the handle. Make it large enough to balance the heavy axe head. The form should pyramid out from the axe handle and continue down in a rectangular shape with a flat bottom. This cap will make for a wicked hard-edged blunt weapon for thrusting and clubbing.

3 Refine the edges and add textures. The sharpened edges of the axe should be notched and split to indicate the wear of years of skull-splitting blows it has delivered. The metal on the sides of the axe should be darker than the sharpened areas. Rub the side of your pencil lead over the side areas to create an overall rough tone. Use hatching to render areas that are worn, scratched or dark with bloodstains.

4 Finish by rendering the handle and end cap. The handle is made of wood, so draw sweeping and swirling lines to suggest grain and knots. Add circular metal studs to the sides of the cap and one large stud to the bottom to make it a more deadly smashing weapon. Next, add a ring at the top of the cap to secure it to the handle. This element should remain relatively smooth, so just use some light crosshatching for texture.

ORC WEAPONRY

Orc weapons and armor are adorned with elements foraged from their surroundings and from their foes, such as horns, skulls, bones and wood. They have the tools and knowledge to work metal, but are not known for highly intricate craftsmanship.

MORNING STAR

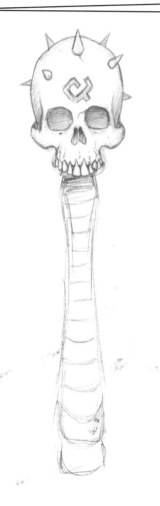

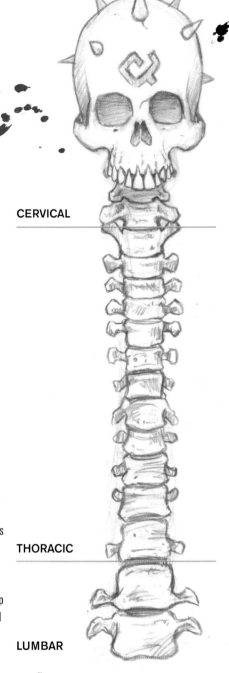

CERVICAL

THORACIC

LUMBAR

1 This morning star is forged from the skull and spine of one of the orc's human victims. Begin with a rough skull shape, minus the jawbone. Draw a line straight down from the bottom of the skull shape to represent the path of the spine.

2 Use a good reference when drawing parts of the skeleton. Begin to cut in the features of the skull and draw the basic shape of the spinal column. Don't make the eye sockets circular—they are much more squared off. The spine is made up of twenty-four vertebrae. You will not need to draw all twenty-four though, because several of the upper (cervical) vertebrae will be hidden behind the skull, and we won't include all of the lower (lumbar) vertebrae. Focus on capturing the overall shape of the spine.

3 Paying close attention to your reference, clearly define the cheekbones as they transition into the rounded form (maxilla) that holds the teeth. Don't get lazy with the teeth—each kind has a particular shape and size.

Now it's time to turn the skull into a functional weapon. Draw randomly sized spikes around the top of the skull. Draw an orcish symbol on the forehead of the skull so that it looks like it has been carved into the bone.

4 Rendering the spine is the final and most difficult step. Use a good reference! Pay close attention to the change in shape and size of the vertebrae as they descend from the cervical to the thoracic to the lumbar. The spine is widest at two separate points: where the cervical and thoracic vertebrae meet and near the bottom of the lumbar vertebrae. The narrower section between these two points makes a great handle with maximum grip and smashing power.

DEFINITION

A morning star is a medieval shafted weapon with a spiked head. It's basically a spiked mace or club.

PAINTING DEMONSTRATION

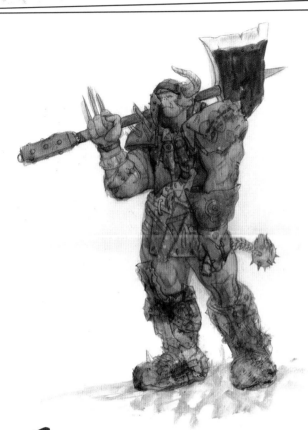

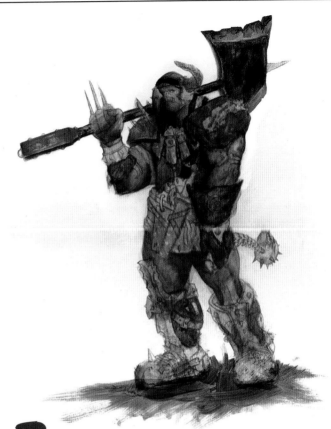

1 Start by loosely blocking in with muted colors. Use a limited palette: Burnt Umber, Olive Green, Burnt Sienna, Raw Sienna and Ivory Black. At this stage, mix the siennas and umbers directly into the other colors for a uniform warmth over the entire figure. Apply the green mixture to the skin, the black mixture to rough iron items like the axe head and the greaves, and put various brown mixtures on all of the areas that are leather and warm metals like gold and copper. Mix the paint with a generous amount of Liquin and apply it very thinly. Use a very loose paint handling so that there is randomness in the marks, which you will later transform into textures such as metal, leather and skin.

2 Add some Turquoise Blue mixed with a generous quantity of Titanium White into the background, and splash in a mixture of Olive Green and Burnt Umber at his feet as the basis for some grass and dirt. Begin to work up the flesh of the figure with thin layers of Green Gold. Start defining some of the different textures. For metal areas such as the axe head, paint a cool gray consisting of Ivory Black, Titanium White and your choice of blues over the warm brown underneath.

TECHNIQUE

MIXING IT UP

Mixing warms and cools is a very important aspect of painting that is often neglected. Light absorbs and reflects color in a variety of ways and will illuminate whatever you paint with these colors. Shadows are also much more interesting when they are filled with color. For example, if you are painting an external setting with a radiant blue sky, mix some blue (usually French Ultramarine) into the shadow areas to tie the foreground and background elements together.

DRAWING THE FOUNDATIONS

Start all of the painting demonstrations in this book with a drawing. Using the painting for reference, copy the basic lines and pay attention to shading and texture.

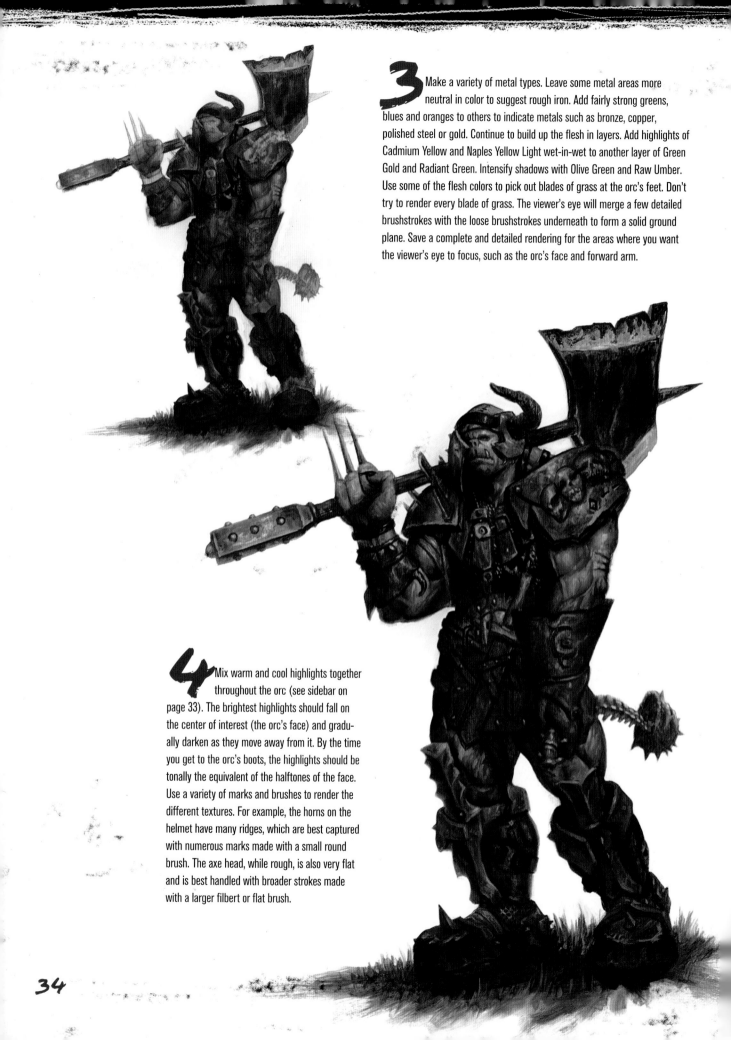

3 Make a variety of metal types. Leave some metal areas more neutral in color to suggest rough iron. Add fairly strong greens, blues and oranges to others to indicate metals such as bronze, copper, polished steel or gold. Continue to build up the flesh in layers. Add highlights of Cadmium Yellow and Naples Yellow Light wet-in-wet to another layer of Green Gold and Radiant Green. Intensify shadows with Olive Green and Raw Umber. Use some of the flesh colors to pick out blades of grass at the orc's feet. Don't try to render every blade of grass. The viewer's eye will merge a few detailed brushstrokes with the loose brushstrokes underneath to form a solid ground plane. Save a complete and detailed rendering for the areas where you want the viewer's eye to focus, such as the orc's face and forward arm.

4 Mix warm and cool highlights together throughout the orc (see sidebar on page 33). The brightest highlights should fall on the center of interest (the orc's face) and gradually darken as they move away from it. By the time you get to the orc's boots, the highlights should be tonally the equivalent of the halftones of the face. Use a variety of marks and brushes to render the different textures. For example, the horns on the helmet have many ridges, which are best captured with numerous marks made with a small round brush. The axe head, while rough, is also very flat and is best handled with broader strokes made with a larger filbert or flat brush.

ELF

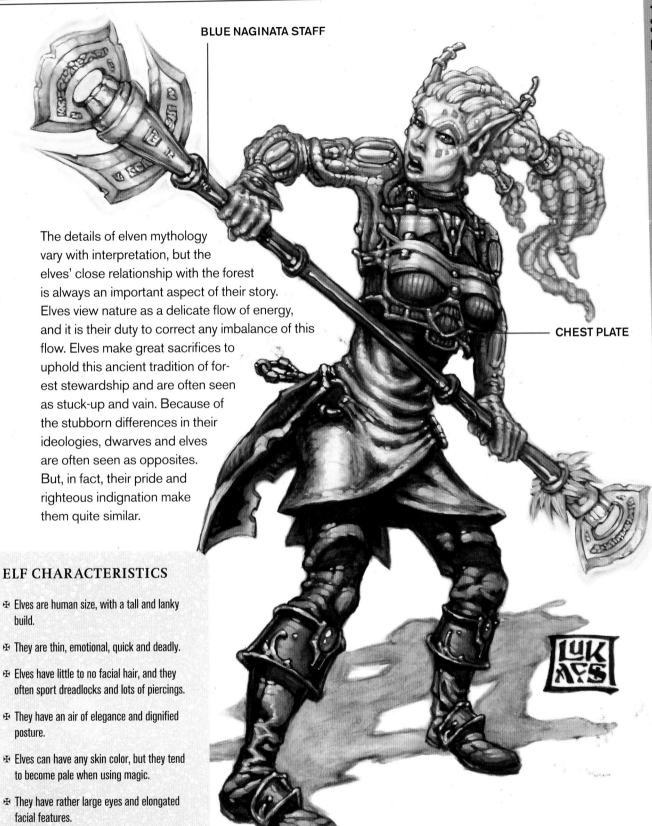

BLUE NAGINATA STAFF

CHEST PLATE

The details of elven mythology vary with interpretation, but the elves' close relationship with the forest is always an important aspect of their story. Elves view nature as a delicate flow of energy, and it is their duty to correct any imbalance of this flow. Elves make great sacrifices to uphold this ancient tradition of forest stewardship and are often seen as stuck-up and vain. Because of the stubborn differences in their ideologies, dwarves and elves are often seen as opposites. But, in fact, their pride and righteous indignation make them quite similar.

ELF CHARACTERISTICS

- ✠ Elves are human size, with a tall and lanky build.

- ✠ They are thin, emotional, quick and deadly.

- ✠ Elves have little to no facial hair, and they often sport dreadlocks and lots of piercings.

- ✠ They have an air of elegance and dignified posture.

- ✠ Elves can have any skin color, but they tend to become pale when using magic.

- ✠ They have rather large eyes and elongated facial features.

- ✠ Most importantly, elves have enormous tapering ears, which can be up to four times the size of a human's ear.

CHEST PLATE

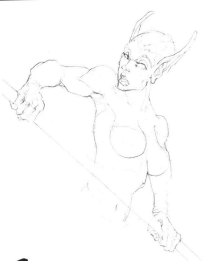

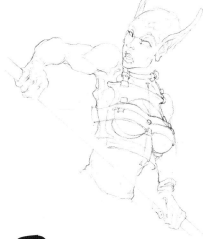

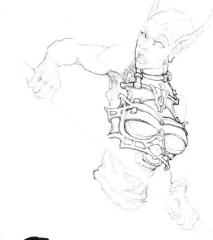

1 Start by drawing the graceful elven surface anatomy. Keeping the movement of the muscles in mind as you sketch, outline the major shoulder and torso muscles.

2 Add a line down the center of the chest, and rough in the symmetrical shapes of the plates, following the surface anatomy that is already in place. Also think about how the folds in the mail fabric will move with the plates.

3 Add more ornamental details to the plate armor and mail, keeping your perspective in mind. Gems, straps, rings and engraved ridges all make great ornaments.

ELVEN WEAPONRY

- Since elves are long-limbed and agile, the armor they wear is light and functional.

- Their armor incorporates tight chain mail into sparse but highly ornate plate armor.

- Elven armor often features Art Nouveau-influenced design. Celtic knot work or symbols of nature are also appropriate.

- The elves' wisdom of nature has granted them the use of powerful magic, which is used both in their armor and weapons.

- Elven weapons should look graceful and refined. Pay special attention in the curves and balance of your weapon design for elves.

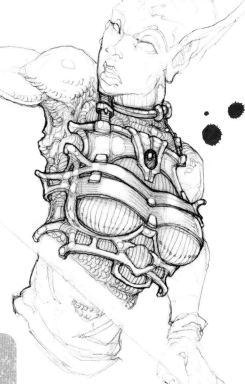

4 Finish up the rest of the shadow shading. Use your eraser to make the highlights. Remember that the light sources are coming from either end of the staff.

DIFFERENT DESIGNS

Don't be afraid to mix new elements into your armor designs. You might like the way a wooden chair is carved, the way a metal rim looks or even the shape of a bird's wing. See if these designs will work on your armor or weapon.

NAGINATA

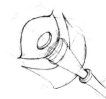

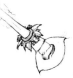

1 Begin the naginata (bladed staff) with a straight centerline, and the opposing lines that create the shape of the blades. Don't worry about detail, and make sure you aren't too heavy-handed with your pencil. This perspective is fairly shallow, so all your ellipses will be at the same depth.

2 Start to define the shape and thickness of the blade assembly by tightening up the arching and opposing shapes of the blades. Also add the full grip and fur rutt. I think about how the blades might be held in place: tied, threaded, riveted or pinioned.

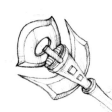

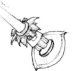

3 Erase the guidelines you don't need and darken the outline of the naginata. Add more assembly details, including the bevels on the blades. Create the bevels by outlining each shape of the blade. Sketch in the reflections and shading. Make the shine from the chrome and silver with dark shading butted up against white highlights.

4 Clean up the rest of your guides. Add the energy lines flowing from the blades. These lines generally follow the outline of the object that's emitting them. Next, add engraved ornamentation on the blades. Create a border within each blade, and fill the inside shape with lettering and patterns. Your elf is now ready to defend the forest.

DEFINITION

A naginata is a traditional samurai weapon. In its most basic form, it consists of a pole with a curved blade on one end.

JAPONISME

When designing elven weapons it's a good idea to look at ancient Japanese weapons. They're very light and efficient and can be wielded very quickly.

PAINTING DEMONSTRATION

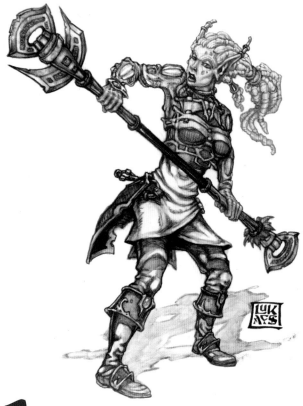

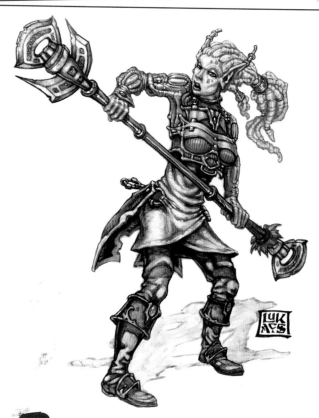

1 Begin the acrylic wash by adding some tone over the whole character, defining the major lights and darks as you go. As you lay in the washes, keep in mind that the two blades along with a warm Burnt Sienna reflection going from the boots to the upper body will act as light sources. Use a combo of Burnt Sienna and Phthalo Blue. Mix in more Burnt Sienna for the lower body and more Phthalo Blue for the metal armor. Add a tiny bit of Alizarin Crimson for the face and hands.

2 Next, map out all the major color groups with transparent oil washes. These washes deepen the darks, set each color group apart from the rest and also make the painting go more quickly. I broke this painting down into these groups: (1) skin and hair; (2) chain mail, armor and ornaments (Manganese Blue and Titanium White); (3) legs and boots (Burnt Sienna faded into armor colors); and (4) glowing blue blades (a wash of Ultramarine Blue with Manganese Blue and Titanium White highlights). The pale skin is done with a very light wash of Magenta and Liquin, with Titanium White highlights mixed in wet. The hair is Naples Yellow Hue worked into the underpainting, then highlighted with Titanium White. Groups 1 and 2 are already finished off with opaque color.

TECHNIQUE

PAINTING LEATHER

1 Begin with a Phthalo Blue and Burnt Sienna acrylic wash. Keep the shadows well defined.

2 Apply a transparent wash of Liquin, Manganese Blue and Burnt Umber.

3 Mix a little of the wash from step 2 with Naples Yellow Hue, Burnt Sienna and Titanium White to create an opaque midtone. Mix a bit more Titanium White into your brush, and make the marks closest to the center of the highlight. Mix in more and more Titanium White, making the marks thinner each time. Finish with an expressive thin dotted highlight line of Titanium White, where the glare is most intense.

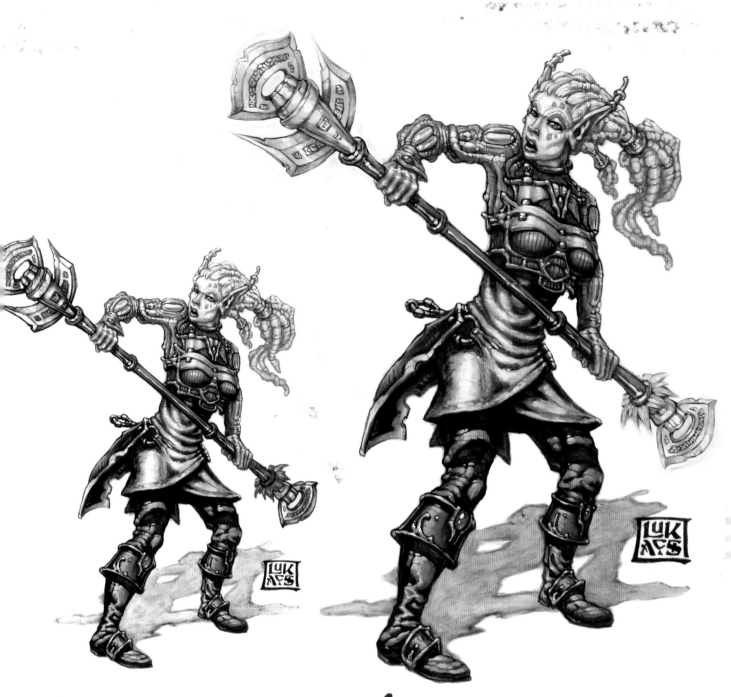

3 Start this stage by letting some of the blue color dry enough that it's a bit more tacky. Then gradually mix Burnt Sienna right into those blues, blending more Burnt Sienna as you paint the upper body down to the boots. The effect will be a gradual fading from blue chest and shoulder armor to green legs and boots, as if the naginata is acting like a big blue spotlight on her upper body.

4 Finish by making the naginata blades glow. Work Manganese Blue into the Ultramarine Blue wash, smoothly building highlights with more and more Titanium White while everything is still wet. Bringing some of the lightest blues and whites right on out past the edge of the blades will add to the glowing effect. Mix Burnt Sienna with just a touch of Cadmium Yellow Deep, and add some orange reflective light to the boots' shadows and metallic parts. Your elf is now ready to defend her forest.

GNOME

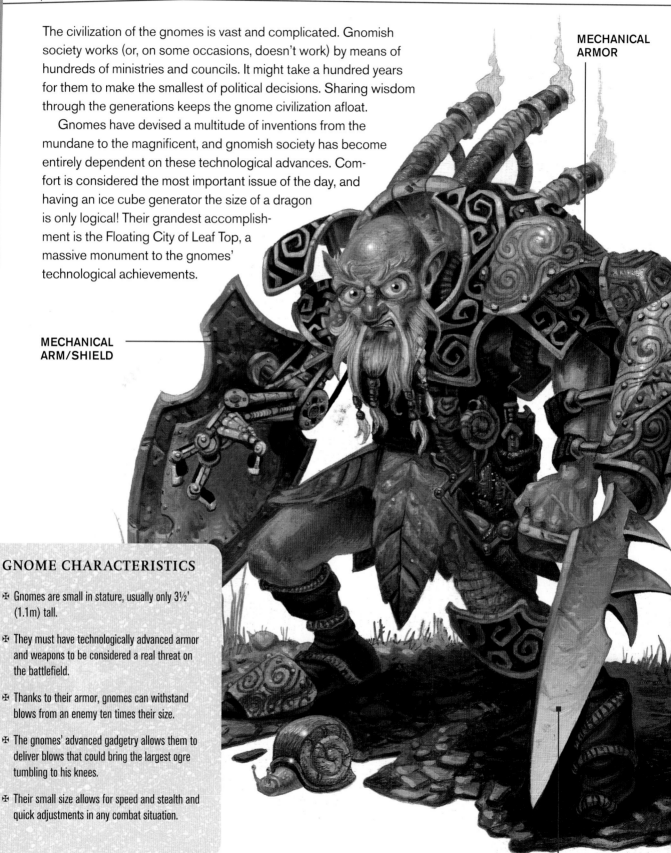

The civilization of the gnomes is vast and complicated. Gnomish society works (or, on some occasions, doesn't work) by means of hundreds of ministries and councils. It might take a hundred years for them to make the smallest of political decisions. Sharing wisdom through the generations keeps the gnome civilization afloat.

Gnomes have devised a multitude of inventions from the mundane to the magnificent, and gnomish society has become entirely dependent on these technological advances. Comfort is considered the most important issue of the day, and having an ice cube generator the size of a dragon is only logical! Their grandest accomplishment is the Floating City of Leaf Top, a massive monument to the gnomes' technological achievements.

MECHANICAL ARMOR

MECHANICAL ARM/SHIELD

GNOME CHARACTERISTICS

✠ Gnomes are small in stature, usually only 3½' (1.1m) tall.

✠ They must have technologically advanced armor and weapons to be considered a real threat on the battlefield.

✠ Thanks to their armor, gnomes can withstand blows from an enemy ten times their size.

✠ The gnomes' advanced gadgetry allows them to deliver blows that could bring the largest ogre tumbling to his knees.

✠ Their small size allows for speed and stealth and quick adjustments in any combat situation.

BLADE

MECHANICAL ARM/SHIELD

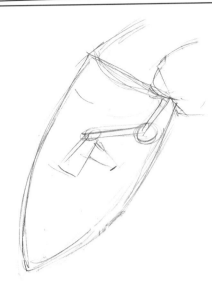

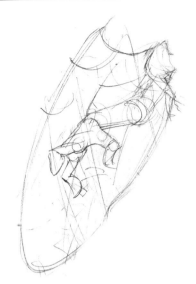

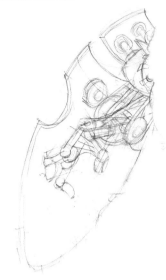

1 Sketch the outline of the basic shape. Think about its size in comparison to the gnome. Draw the mechanical arm. Use rectangles for the hand and thumb. The thumb is about the size of the palm.

2 Now, make the shield shape more interesting. On the inside of the initial sketch, draw "searching" lines to find an interesting subtraction. Then, cut into the shape of the shield with broad pencil strokes. Develop the shapes of the arm and hand.

3 Erase extra pencil marks. Add detail to the mechanical arm. Circles and rectangles work best. These shapes will become the gears and levers that make the arm work.

TECHNIQUE

CROSSHATCHING

1 Start by drawing relatively even lines all in the same direction.

2 Then draw lines in the opposite direction. The more you do in the opposite direction of each set of lines, the darker the surface will be.

3 Crosshatching works well for adding texture and shading to characters such as the gnome.

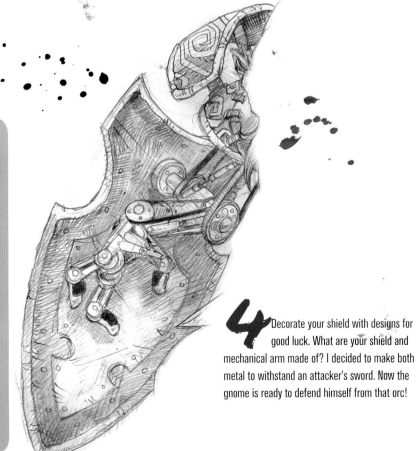

4 Decorate your shield with designs for good luck. What are your shield and mechanical arm made of? I decided to make both metal to withstand an attacker's sword. Now the gnome is ready to defend himself from that orc!

BLADE

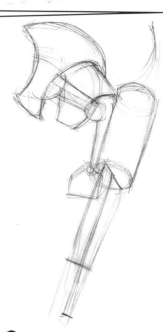
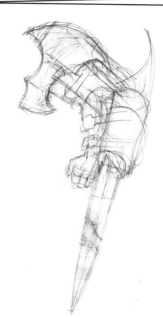
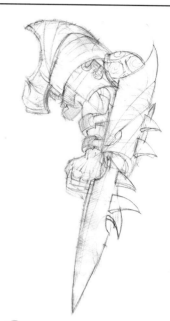

1 Draw the basic shapes of the armor and blade. The basic shape for the arm brace is a cylinder. Draw the blade by drawing a line down the center to establish the tip. Draw a cross to show where the base of the blade is and where the blade begins to curve. Add some cylindrical shapes that will make up the armor and blade brace.

2 Now that you have your basic shape, carve into the shoulder armor that houses the gears and pistons with curved lines.

3 Establish and refine the decorative elements. Make the pistons more prominent. I added a turtle shell just for fun! Add some spiky barbs on the blade.

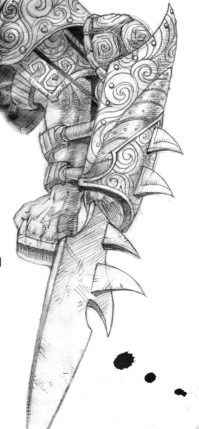

TIPS

- Drawing is like sculpting only with a pencil.

- Don't be afraid to draw through other parts of your drawing.

- Start out thinking big design and end up thinking small design.

- You are in control of your drawing! Your drawing doesn't control you!

- Have fun!

4 Remove any extra pencil marks. Now, go crazy with detailing. I added texture with tiny bolts and swirls. Create designs that are inspired by nature or intricate geometrical designs. Think about the edges. Are they worn down by years of combat or are they fresh off the blacksmith's anvil? Orcs beware! This gnome has got it in for you!

DRAWING DEMONSTRATION

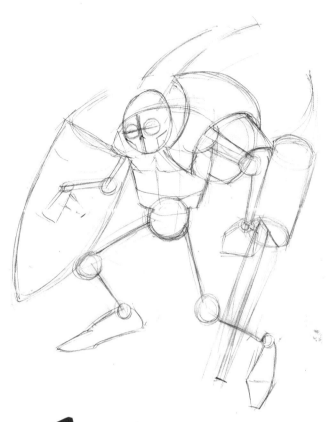

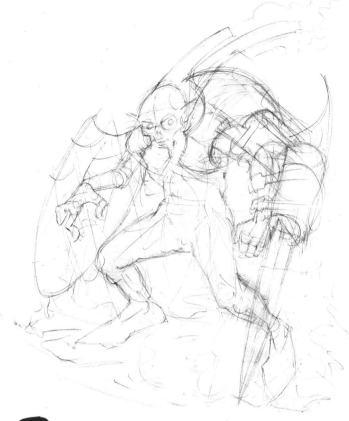

1 First establish your gesture sketch. Break your figure down into four elements: the head, torso, arms and legs. Draw circles to establish the location of the joints. Draw a larger circle for the hips and attach the legs to it. Draw a cross in the center of the head. This will help you figure out where to draw the eyes and nose. Next, fit the armor and weapons into your composition. The way a character holds his weapon can show how heavy or light it is. This gnome is hunched over to show the weightiness of his gear.

2 Clean up your gesture sketch with a kneaded eraser. Next, draw the meaty parts of the figure. Use an anatomy book or look at yourself in a mirror for reference. Draw the eyes, ears, nose and mouth. The gnome's ears are pointed (similar to elf ears). To form the eyes, draw circles. Establish a brow line with a line over the top part of the eye. The mouth should stretch from about pupil to pupil.

GNOME GADGETRY

When drawing your gnome think about the technology he would use in combat. Would your gnome have a long spear to reach the enemy, or would he have a blunt weapon to get up close and personal? Think about how it would work. Are there gears and levers, or is it made of magic?

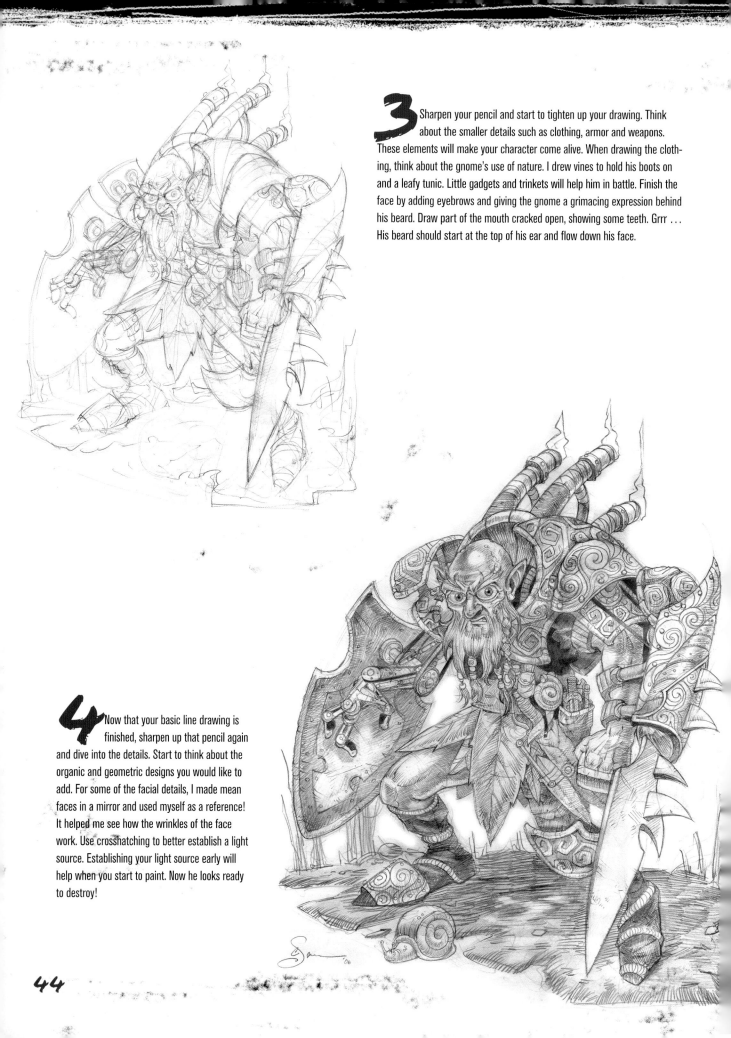

3 Sharpen your pencil and start to tighten up your drawing. Think about the smaller details such as clothing, armor and weapons. These elements will make your character come alive. When drawing the clothing, think about the gnome's use of nature. I drew vines to hold his boots on and a leafy tunic. Little gadgets and trinkets will help him in battle. Finish the face by adding eyebrows and giving the gnome a grimacing expression behind his beard. Draw part of the mouth cracked open, showing some teeth. Grrr . . . His beard should start at the top of his ear and flow down his face.

4 Now that your basic line drawing is finished, sharpen up that pencil again and dive into the details. Start to think about the organic and geometric designs you would like to add. For some of the facial details, I made mean faces in a mirror and used myself as a reference! It helped me see how the wrinkles of the face work. Use crosshatching to better establish a light source. Establishing your light source early will help when you start to paint. Now he looks ready to destroy!

DWARF

When I was younger, dwarves held my fascination more than many mythological characters because I resemble one! Their height and interesting features were familiar to me. I liked dwarves also because they prove you don't have to be big to be strong. Today, drawing their squat proportions, big burly facial features and piles of coarse hair is second nature to me.

Dwarf strongholds are very heavily fortified, taking us beneath the hillocks and into distant mountain regions. Dwarf society is secretive and remote, and dwarves tend to be stubborn and intolerant to change. Their culture is patriarchal, militaristic beyond sensibility, and their religious ceremony and rites of passage revolve around feats of strength, deprivation and outrageously brutal combat.

HELMET

SHOULDER ARMOR

LOLLIPOP MACE

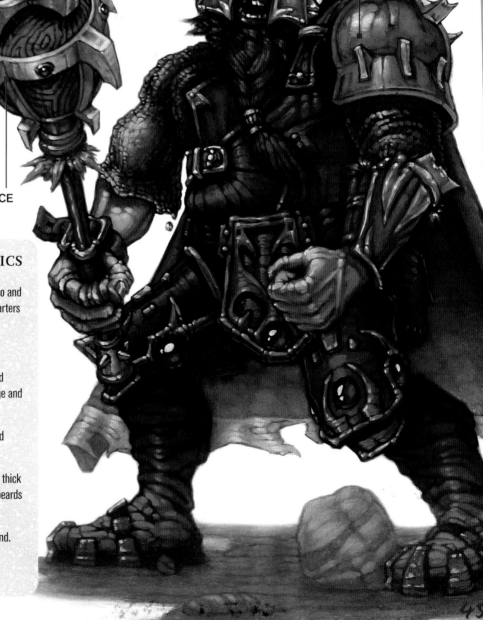

DWARF CHARACTERISTICS

✠ Dwarves are squat, especially in the torso and legs. They're about one-half to three-quarters human size.

✠ They have big hands and feet.

✠ Dwarf faces are craggy and wrinkled and have a large, wide nose with broad bridge and a large Cro-Magnon brow.

✠ Male dwarves have a huge mustache and beard that often hides the lips.

✠ Female dwarves have big hips, and their thick lips are apparent since they don't have beards to hide behind.

✠ Dwarf skin is pale from living underground.

ARMOR

 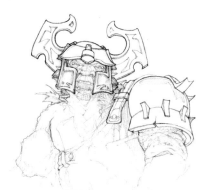

1 Sketch out the dwarf's surface anatomy. Then, lightly wrap the armor guidelines around the head and shoulder. Add a centerline for the helmet so that you can keep the horn design symmetrical.

2 Add the hooks to the shoulder, making them all point upward for maximum damage. Then, add the strapping. Give the helmet more details by outlining the ornamentation that will appear on its horns.

3 Darken your outlines, and erase the guidelines. Add some shadows, keeping in mind that the light source is coming in from the left front of this dwarf. Each shadow will fall to the right of the object casting it.

4 Sketch in the rest of the highlights on the clasps and strapping and the big shiny highlights on the helmet and shoulder piece. Then, add the shadows and reflections on the metal surfaces, and your dwarf is ready for battle.

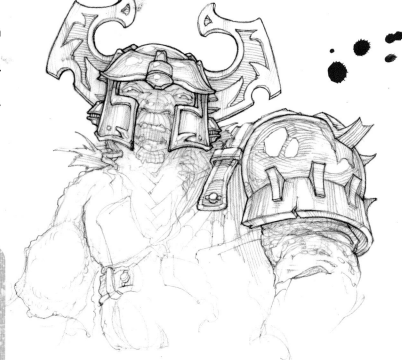

BODY ARMOR BASICS

Know the body part you're armoring. Think of armor as an extension of the bone and muscle structure it's covering; it must bend and move with that structure. Imagine helmets as large heads, and shoulder armor as big metal deltoid muscles.

LOLLIPOP MACE

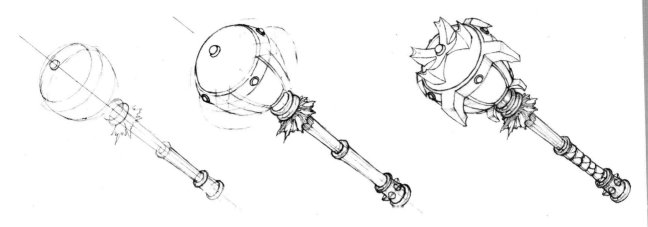

1 Begin with a straight centerline and some basic shapes, including the main weight, the main shaft and the bands. Draw lightly and remember that circular parts will appear elliptical because we're seeing them in perspective.

2 Add the gem-studded bands, the grip and the studded end. The bands will follow the sphere of the main weight. Begin roughing in the perspective guidelines that define the hooked barbs on the main weight and the end of the handle.

3 Add the hooked barbs to the bands and braided leather to the grip. Lay down cross-shaped guidelines that wrap around the main weight. Then, create the barbs that point upward and downward. Erase the guidelines you don't need, and darken the outline of the mace.

4 Add the pattern of the malachite stone weight. Malachite is a stone that has concentric but random ring shapes that look a bit like wood grain. Bring some shading in to the barbs and bands. Use your eraser to create the highlights in the gems, and your mace is finished.

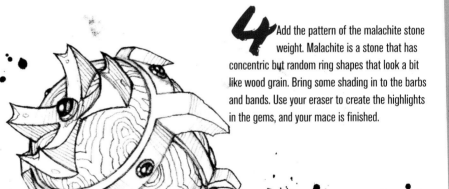

DWARVEN WEAPONRY

- Dwarves are known for their metal-working skills. The dwarf is the epitome of the rugged blacksmith, and his armor and weaponry are often ornately engraved.

- Dwarf armor tends to be form-fitting.

- Other weapons for dwarves include ornate axes or short swords.

- Make the weapons really big to show the dwarf's amazing strength.

- Dwarves really shine in numbers. Try drawing an army of individuals with similar metal shields, or groups of dwarves working around large cannons or catapults.

PERPLEXING PERSPECTIVE

If you're having trouble imagining the perspective, and don't have a photo reference, hold a wooden dowel or pen barrel in the same position as your weapon and draw from that.

PAINTING DEMONSTRATION

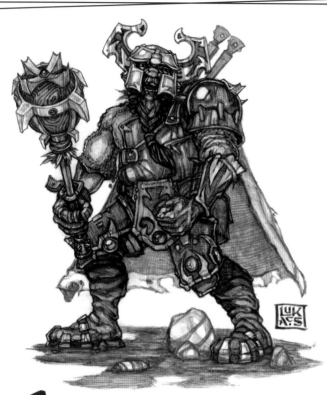

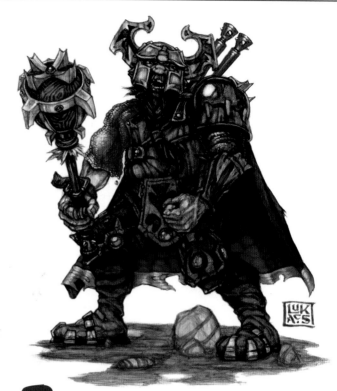

1 Start adding darks to your sketch. Get some tone over the whole character. Create some interesting line work, drawing with the brush as you would a pencil as I've done with the curls of beard hair. Start defining the lights and darks with an acrylic wash. Mix in more Phthalo Blue in the armor, more Burnt Sienna in the skin tones and equal amounts of both in the malachite mace.

2 Map out all the major color groups with transparent oil washes. Add Liquin to the oil paint to make it thin enough for washes. I broke this painting down into these groups: (1) chain mail, cloak and weapons on back (Ultramarine Blue, Burnt Umber and Magenta); (2) malachite stone on mace and green leather armor (Ultramarine Blue and Transparent Yellow); (3) steel helmet, shoulder armor and boot tips (Ultramarine Blue and Manganese Blue); (4) boots, beard and skin (Burnt Sienna and Burnt Umber); (5) shadow and rocks (Burnt Umber and Ultramarine Blue). Each of the different materials and metals gets a wash of transparent color. These washes deepen the darks, differentiate each color group and make the painting process go more quickly.

TECHNIQUE

PAINTING SKIN

1 Begin with an acrylic wash of Burnt Umber and Burnt Sienna.

2 Apply a transparent oil wash of Liquin, Burnt Sienna and Burnt Umber.

3 Use a little of the wash from step 2 mixed with Magenta and Naples Yellow Hue. Blend the colors together right on the painting. This will create an opaque midtone, and your darks will change to a more purplish hue where the opaques blend into the transparent wash. Then use Titanium White to paint in the highlights, blending them in as you go. Finally, blend Cadmium Yellow Deep into the reflective orange light on the bottom of the nose, and blend Cadmium Red Deep and Burnt Umber into the eyelids and brow.

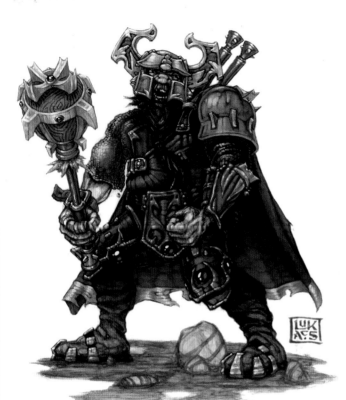

3 Mix the opaque colors to match each group: (1) chain mail, cloak and weapons on back (Ultramarine Blue, Manganese Blue, Titanium White and Magenta); (2) malachite stone on mace and green leather armor (Burnt Sienna, Manganese Blue, Yellow Green and Naples Yellow Hue); (3) steel helmet, shoulder armor and boot tips (Manganese Blue, Ultramarine Blue, Titanium White and Burnt Umber); (4) boots, beard and skin (Burnt Sienna and Burnt Umber); (5) shadow and rocks (Burnt Sienna, Cadmium Red Deep, Magenta, Flesh Tint, Cadmium Yellow Deep and Titanium White). Start to put in a midtone; remember that your light source is left and front. Gradually add lighter opaque tones right on top of the still wet darker shades, blending as you go. Most of the blue steel parts and green leather parts are now complete.

4 The skin on the face and hands should be pale. To achieve this effect, wash on little bits of transparent Magenta and Burnt Sienna in the shadow areas before you mix your group 4 opaque tones. At the dwarf's feet, aggressively blend in a mixture of transparent medium and Titanium White with a large bristle brush to create the effect of cold vapor creeping up from the ground. Be sure to avoid the dark areas you've put in on the feet and legs.

LUK A·S

LUK A·S

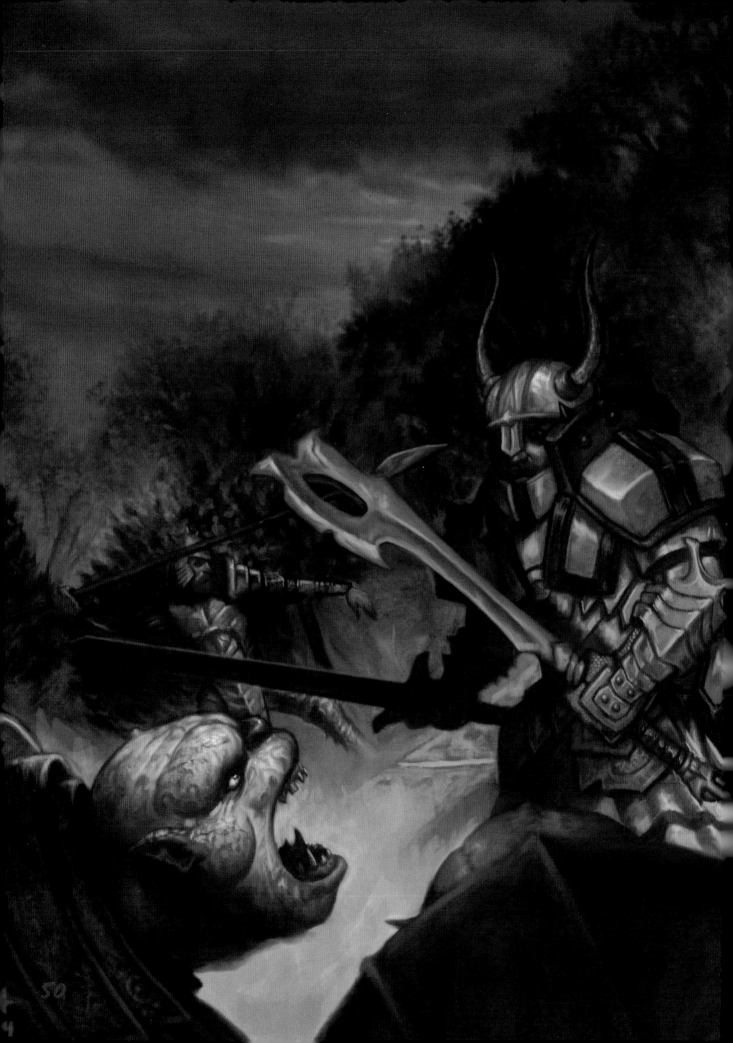

50

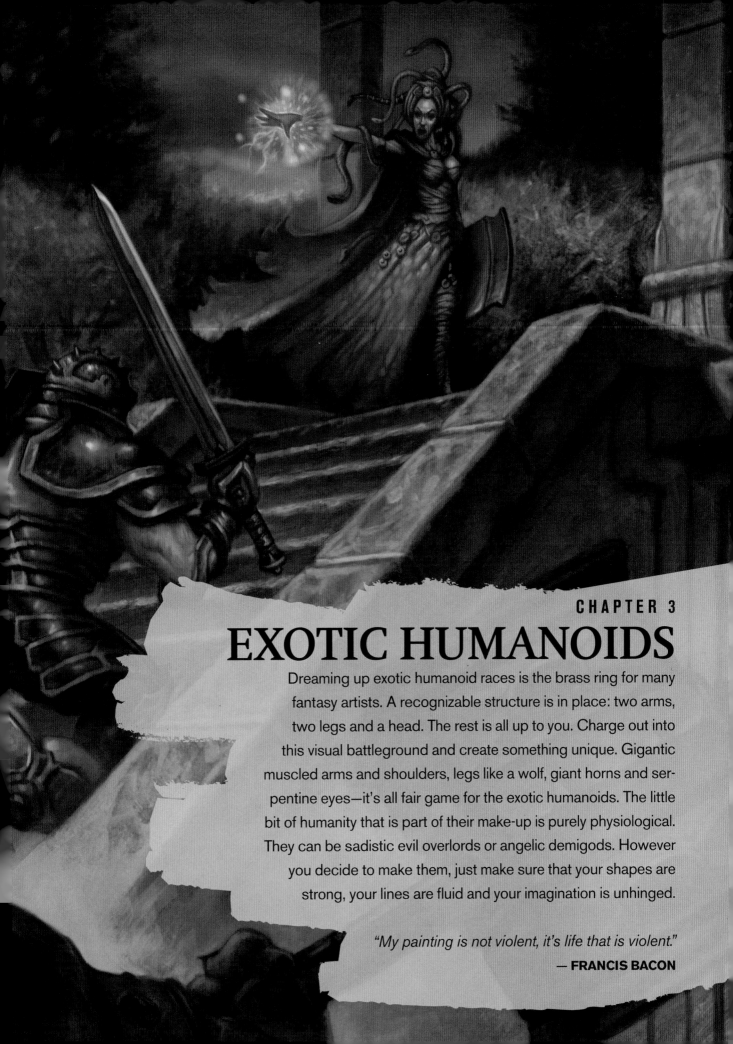

EXOTIC HUMANOIDS

Dreaming up exotic humanoid races is the brass ring for many fantasy artists. A recognizable structure is in place: two arms, two legs and a head. The rest is all up to you. Charge out into this visual battleground and create something unique. Gigantic muscled arms and shoulders, legs like a wolf, giant horns and serpentine eyes—it's all fair game for the exotic humanoids. The little bit of humanity that is part of their make-up is purely physiological. They can be sadistic evil overlords or angelic demigods. However you decide to make them, just make sure that your shapes are strong, your lines are fluid and your imagination is unhinged.

"My painting is not violent, it's life that is violent."
— FRANCIS BACON

MEDUSA

The toughest of warriors, battling through the toughest of conditions, struggles on for one reason: for his loved ones at home. For the Medusa, the lull between battles is the perfect time to strike. The warrior's heart is open, and his mind is clouded by violence. If a warrior's path intersects with the Medusa, he forgets his true love.

Many a battle-hardened warrior has abandoned his troops to spend the night with the Medusa. In the morning, he realizes his mistake, but it's too late! She blinds him and holds him under her spell, using him to carry out her own schemes and devices. Entire armies have crumbled under the Medusa's gaze. The spell can only be broken when a warrior comes face to face with his true love and his heart remembers the love he left behind.

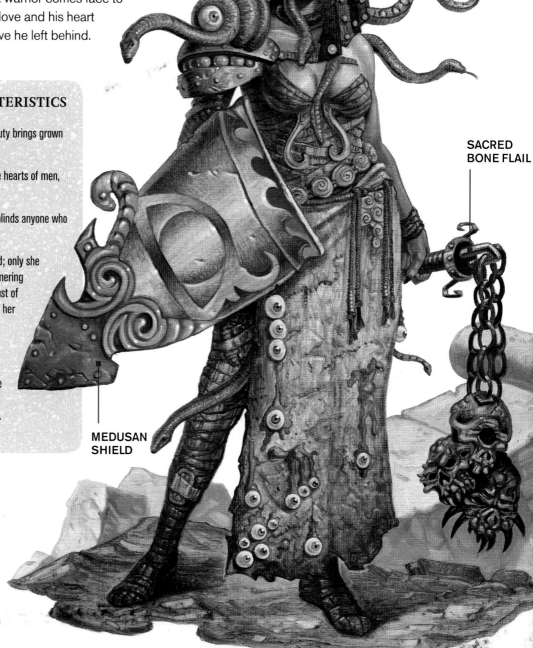

SNAKE HEADDRESS

SACRED BONE FLAIL

MEDUSAN SHIELD

MEDUSAN CHARACTERISTICS

✠ The Medusa's extraordinary beauty brings grown men groveling to their knees.

✠ Her evil gaze goes straight to the hearts of men, filling them with false love.

✠ The slithering snake headdress blinds anyone who gazes on the Medusa.

✠ The Medusan shield is enchanted; only she can wield it in defense. Its shimmering glow can be seen through the dust of battle, attracting the attention of her next victim.

✠ The sacred bone flail is a close-combat weapon. Once a warrior is intrigued and entrapped by the Medusa's charms, a quick bash will put him into eternal slumber.

MEDUSAN SHIELD

1 Draw the basic outline of the shield. Start with a triangular shape, and curve the lines a bit to give the shield some weight.

2 For interest, add some curved shapes on either side of the shield. Sketch in the area for the "ever-seeing eye" design. Draw a circle for the iris and two curved lines on top and bottom. Start pencilling in the basic patterning of the shield. I decided on a swirling organic pattern on either side of the shield.

3 Extend the bottom of the shield with another triangular shape. Draw flat barbs on either side of the larger triangle. Turn one of the side curves into a snake's head. Add a dot for the eye. Draw another set of lines around the iris of the main eye motif to add thickness to the eyelid. Draw stylized eyelashes on the bottom and a curvy eyelash on the top.

I wanted to simplify my design, so I decided to remove some of the elements I drew earlier.

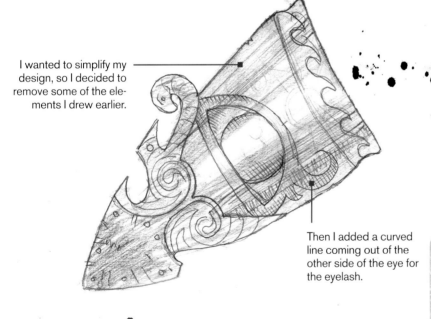

Then I added a curved line coming out of the other side of the eye for the eyelash.

4 Erase all extra pencil marks. Draw a line parallel to the top of the shield. Draw a wave design in this new space. Add curved lines around the snake's body. Erase the extra barb and curve from the right side of the shield. We want the dangerous side of the shield to be on the side with the snake. Draw some bolts on the bottom part of the shield to keep those pieces together. To have good defense you need to have even better offense!

"SNAKY" SORCERY

When you draw your Medusa think about how she wields her power over her captives. Maybe it's how she's standing in a powerful gesture? Or perhaps she has her hand outstretched to lure in a victim to her snare? The snakes in her headdress are alive. Could they help her point out the perfect victim?

MEDUSAN HEADDRESS

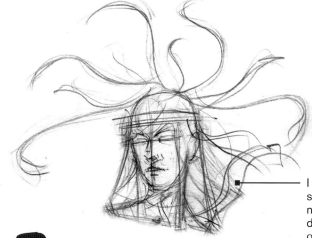

I drew in an extra snake line around the neck covering, but I decided to remove it on the next step.

1 First draw the basic head shape. This will help you place the snake headdress. You don't want the headdress to cover her eyes, so make sure you draw a crosslike mark on the face to establish the location of the eyes.

2 Draw some swirling lines to figure out where those crazy snakes should start and stop. Start to rough in the lines of her neck coverings. Add the base of the headdress. At this point it is almost like a headband.

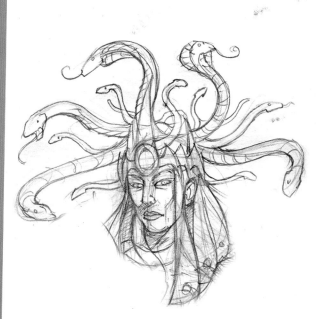

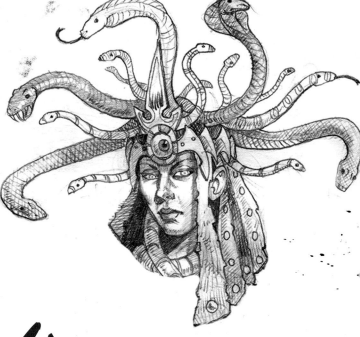

3 Clean up your drawing with a kneaded eraser. Now flesh out those snakes—think of them as curling tubes. I added some circular lines to the design of my snakes. Turn the neck covering into strips of worn leather with studs in them. Now, work on the headband. In the center, draw an oval with a smaller oval in it. This will be the all-seeing eye. Draw overlapping triangle shapes around her head. This shape is similar to bat wings. Then draw a larger triangle above the eye. Cut some shapes into the triangle for interest.

4 Use your pencil to clean the edge lines and clearly define what's in front and what's in back. Add some shading to make her face pop. Determine your light source and use crosshatching to render the headdress. I decided to place the light source on the right. To finish the snakes, draw scales on their slippery skin. Use crosshatching to form the scales' geometric shapes. Use circles to complete the eyeball in the middle of the headband. Now she will be able to quickly manipulate a warrior's mind!

SACRED BONE FLAIL

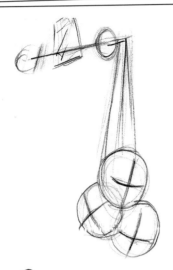

1 Start with a line for the handle. It should be half the length of the chain. Add an oval at the top of the handle. This will be where the chains attach. Draw three lines for the chains. Add three ovals for the skulls. Draw a crosslike mark on each oval to help determine the position of the faces.

2 Draw some smaller ovals on the handle to build thickness. Draw a line in a backward L-shape on the tip of the handle where the chains attach.

3 Define the skulls a bit more by carving out the cheekbones. Use small ovals to form the chain links. Now draw an oval on the tip of your handle. This will be the link that holds the chains. Draw an oval around the handle. On either side of the handle draw two swirling curved lines. The large oval will help you space the swirling curved lines. Draw another oval behind the first oval you drew on the handle. This will give the handle tip its edge.

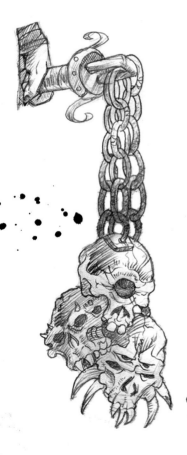

4 Use an eraser to remove any unwanted pencil marks and tighten up your edge lines. Add some bolts on the side of the tip of the handle to hold everything in place. Polish up the curves on the hilt a bit (they should look like question marks). Add the connecting link on the tip of the handle by drawing a rectangle with a smaller rectangle inside. Offset the smaller rectangle a bit so that it looks like it recedes in space. Define the chains by adding a smaller oval to the inside of each link. Draw a reinforced steel plate to attach the chain to the top skull. Finish rendering your skulls. I wanted each skull to have its own personality. One's a cyclops, and another's got four eye sockets and huge spikes growing out of its mouth. Have fun with these guys!

DEFINITION

A flail is a medieval weapon composed of one or more weights attached to a shaft with chains.

DRAWING DEMONSTRATION

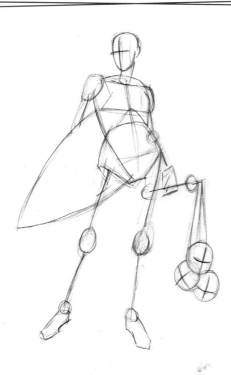

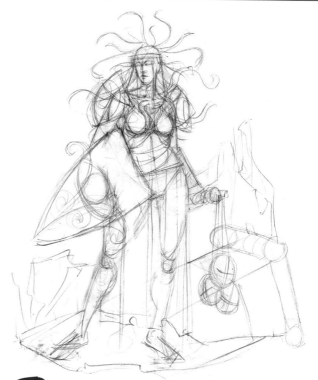

1 Start with a gesture sketch. Break the full figure down into smaller elements like the head, torso, arms and legs. Draw a cross on the head to establish the center of the face. Also draw a cross in the center of the torso to help with anatomy. Draw circles to give yourself an idea of where the joints break down the arms, legs and shoulders.

2 Flesh out those meaty parts of the anatomy with shapes that show weight and form. I used circles for the knees and exclamation point shapes for the calf muscles. Even the smallest of details are comprised of simple shapes. Start thinking about the big picture issues like how the armor might wrap around the body or shoulder. For example, the lines of the shoulder armor should be parallel to those of the arm. Follow the contours of the body. Map out the location of the eyes, nose and mouth. Look at fashion models in magazines to figure out the facial proportions.

TECHNIQUE

WRAPPINGS

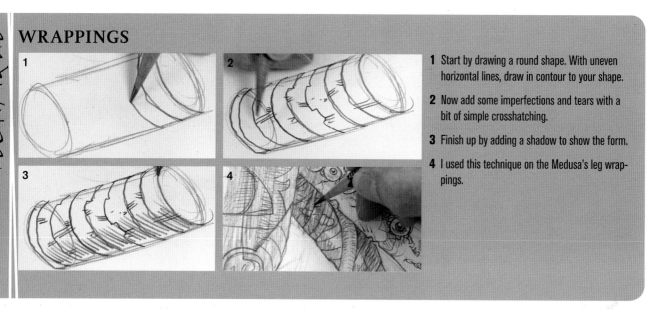

1 Start by drawing a round shape. With uneven horizontal lines, draw in contour to your shape.

2 Now add some imperfections and tears with a bit of simple crosshatching.

3 Finish up by adding a shadow to show the form.

4 I used this technique on the Medusa's leg wrappings.

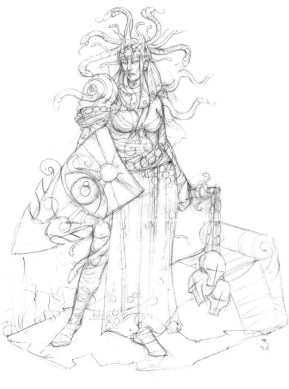

3 Clean up your drawing using a kneaded eraser. Sharpen a pencil and tighten up your line drawing. Draw in the details and polish your edge lines. Use circles to establish the placement of the eyeballs on her apron and belt. You'll notice that there are certain elements that I changed, such as the shield ornamentation. You are in control of your drawing and can decide what details to leave in or take out.

4 Erase any leftover unwanted pencil marks. Determine your light source and add crosshatch shading to tighten up the line drawing. This will help when you get to the painting stage if you decide to do so. Use a sharp pencil to polish up the details. Sharpen the edge lines and finish the eyeballs on her apron. The eyeballs look like they've been yanked out of their sockets! Draw them with circles and squiggly lines to show the entrails of the eye. Now she's ready to steal the hearts of men!

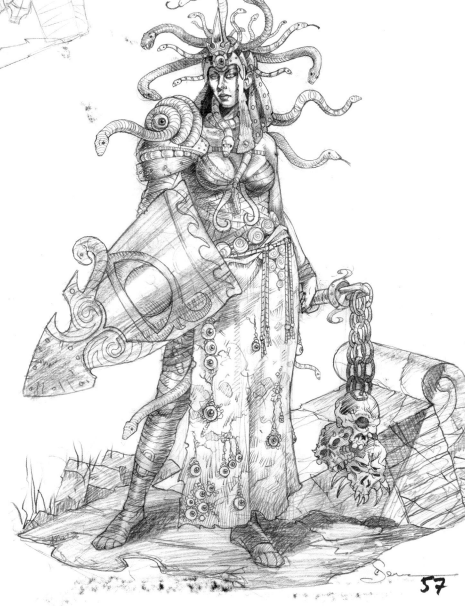

CREAGAL

The earth-splitting blasts of horns and thundering booms of hide-covered drums signal the beginning of a Creagal charge. As a society, the Creagal choose to never speak. Their battlefield strategies unfold like a bloody ballet directed by the cues of their musical corps. Commanders flash their swords through the air with precision as a visual cue to their troops, and subtle body movements are used as a form of communication.

Also, Creagal society makes no distinctions based on gender. They are only interested in skill, honor and obedience. Throughout their history, many female Creagal have risen to the seat of Skyrth Brek, the supreme commander of the Creagal war machine, or other positions of power mostly reserved for males in other societies.

Although the Creagal do not speak, they take great pride in their arts. Musicians are viewed as clerics, healers and military strategists. The Creagal have crafted a wide variety of musical instruments to help convey their emotions, and great symphonies both beautiful and horrible have been written throughout their history. The harmonious tones accompanying Creagal on the march are most often met by screams of terror from the enemy, for the Creagal are merciless in battle and relentless in their desire to cleanse the world of filth speakers (anyone who uses a spoken language).

CREAGAL CHARACTERISTICS

✠ Creagal are bipedal creatures with mostly humanoid features: two arms, two eyes, two ears, and a nose and mouth (the two latter features are rarely seen by anyone).

✠ They are average human height and weight.

✠ Creagal have only three fingers per hand and three toes per foot.

✠ Creagal are covered from head to toe at all times, either by clothes or armor.

✠ Their armor is very ornate. Elaborately designed armor is a mark of status among the Creagal.

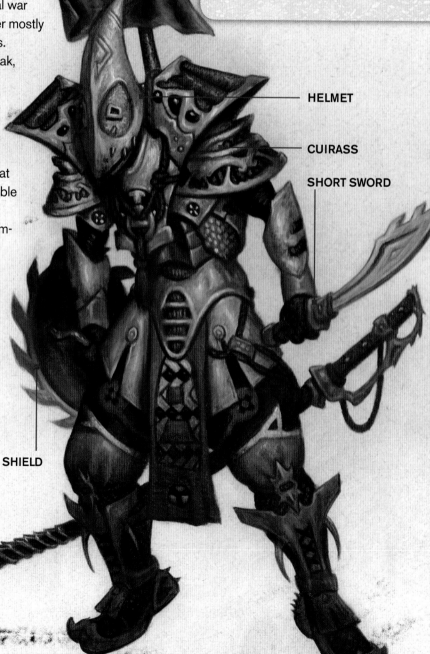

HELMET

CUIRASS

SHORT SWORD

SHIELD

CUIRASS

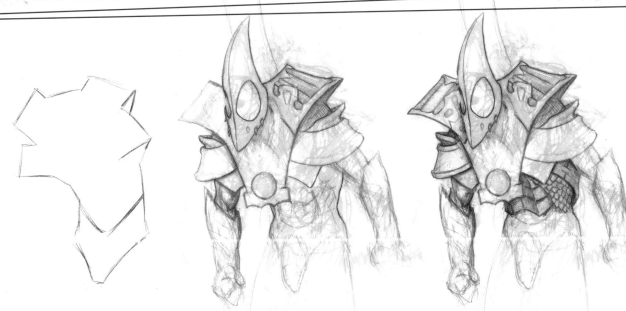

1 A cuirass is usually comprised of two pieces, a breast plate and a back plate. I'm expanding the design to cover the shoulder plates as well. Draw large overlapping shoulder plates at an angle to complement the conical helmet.

2 The uppermost piece of armor will be a large V-shaped piece that wraps over the shoulders and covers the chest, ending at the upper abdomen. Beneath this, draw narrow individual metal bands to cover the Creagal's shoulders laterally. Individual bands allow for increased mobility. Two diamond-shaped plates protrude from beneath the bands to protect the pectorals.

3 Beneath the pectoral plates, draw a smooth, sweeping arch that wraps around the figure to form the bottom edge of the back plate. This overlaps a scale-mail vest that adds further protection to the vital organs on the sides of the abdomen. Underneath the mail vest is a network of layered metal bands that wrap around the Creagal's abdomen.

4 Borrowing from the Japanese, tie the armor together with a network of silk cords. Add inlaid jewels, fine metalwork patterns and sections of padded leather to the metal plates. You will eventually begin to develop your own design sense for the little details like the metalwork patterns. I tend to keep things simpler and more geometric, incorporating some overlapping elements to break up the forms. This will contribute significantly to the initial design concept of combining Eastern and Western armor.

DEFINITION

A cuirass is the light armor that covers the torso of a warrior. It was traditionally made of leather and can also be called a corselet.

SHIELD

1 Start your shield design by drawing a simple circle with a compass. This will allow you to establish a center point for the shield and will influence the rest of the design.

2 Draw another circle that is approximately 70 percent of the size of your original circle. Then, compress your compass a tiny bit and draw another circle within that one. This will create a nice uniform band to encircle a decorative centerpiece.

3 A plain round shield would be too pedestrian for our mighty Creagal warrior. Borrowing a design element from the short sword (see page 62), notch the edge of the shield with evenly spaced sharp tines. This will add striking (offensive) ability to an otherwise exclusively defensive weapon.

CREAGAL WEAPONRY

- Combine themes from Japanese and European medieval armor to create the Creagal's combat attire.

- A Creagal's helmet should cover its entire head with only small openings for the eyes. This will contribute visually to their mysterious nature.

- Think in layers when designing the Creagal's armor. Examine the hard shells of insects and crustaceans for design ideas.

- Repeat themes throughout the armor to create unity.

4 To complete the shield, we need to design a cool centerpiece. A growling demonic sculptural relief will strike fear into the heart of the enemy. Draw in the demonic head using a hexagonal shape that uses the same central point as the shield itself. The individual points of the hexagon will be the guides for the crown of the skull, the cheekbones, and the chin of the beast. Surround the head with an ornate raised iron sunburst. The design should be uniform with eight riveted points focusing back in on the demon head. We now have a shield worthy of a Creagal, combining elegant artistry and precision design.

HELMET

1 The Creagal's helmet should combine elements of both Japanese helmets, which never covered the face, and European full-face helmets, but it should have a unique shape of its own. In this case, it's an inverted cone shape, like a great metal hood.

2 Refine the shape of the cone to make it curve like a giant claw. Create its centerline to add form. Since we are seeing the helmet at a three-quarter view, the centerline will run to the left of center. Block out large egg-shaped insets around the eye areas. Keep in mind that the shape on the left needs to wrap around the helmet, so a large part of it will not be visible. These insets will become more refined eyelets later on.

3 Draw some deeply etched lines near the top of the helmet. Keep them fairly geometric in nature and in harmony with the rest of the figure's design details. Finally, create a series of small spikes near the base, running roughly along the jaw line. These can be utilized offensively in close-quarter combat.

4 The eyelets should be small. Draw a trapezoid-shaped opening with a slightly raised metal edge. Next, make a small oblong indentation beneath the eye. An opening at the bottom of this shape will allow some air to reach the Creagal's war-burnt lungs.

ABOUT FACE

The Codesh Hert, the governing code of the Creagal, requires that their faces be covered at all times. Creagal vanquished on the battlefield often have their helmets taken as trophies by their enemies, yet their true face is always hidden behind a shroud of ritual scarring and tattoos.

SHORT SWORD

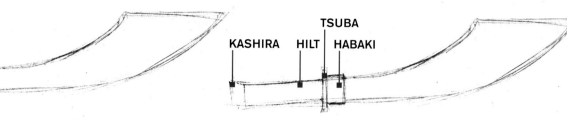

1 This blade is influenced by Japanese design, but I added some elements of the machete so that it would be more exotic than the traditional Japanese tanto. Start out with a shape that is narrow at the hilt and widens out toward the tip. A nice balance between curves and straights always makes for a solid design.

2 The handle of a traditional Japanese blade is made up of a rectangular collar around the blade (habaki), a flat, round guard (tsuba), an oval-shaped hilt and a pommel that wraps tightly around the hilt (kashira).

KASHIRA HILT TSUBA HABAKI

3 Carve out some equally spaced deep notches on the top of the blade. These will not only improve the design; they'll add a new element to the offensive capabilities of the blade. Now it can be used to hack and saw as well as stab and slice.

4 Tighten up the lines by erasing any extraneous marks and darkening final smooth, crisp lines. Create a groove that runs along the spine of the blade to give it some depth. Add the triangular design inscribed in the heart of the blade. Draw an overlapping diagonal cloth wrap for the hilt to improve the Creagal's grip. Add several rivets to the hilt and pommel to hold it all together. Finally, add a decorative, yet geometric design element to the habaki. You can use your imagination on little details like this; just make sure it fits harmoniously with the design themes on the rest of the figure's armor and weaponry.

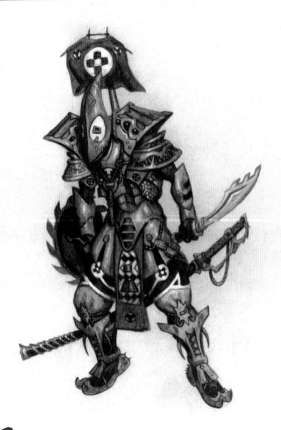

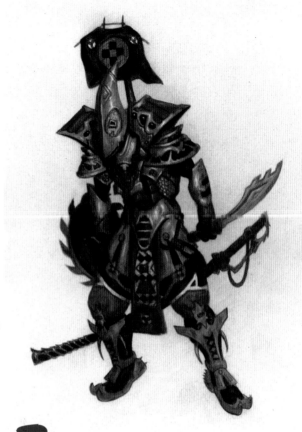

1 Begin by adhering the drawing to Masonite. Apply acrylic washes of Burnt Umber to build up the darks. Mix several different values of Burnt Umber and Titanium White on your palette and use them to build up your midtones. Finally, use straight Titanium White to bring up intense highlights.

2 Now, begin applying thin layers of color in oils. Some colors are naturally transparent; others are opaque. If you look on the label of the oil paint, it will tell you its level of transparency. To make opaque colors appear more transparent, mix the pigments with an oil-based medium such as Winsor & Newton's Liquin.

With such elaborate armor, color choices can be difficult. Your color choices should follow the premise of our overall design (the combination of Western and Eastern influences). Western plate armor was made of metal and leather and therefore was very neutral in color, while Japanese armor was made of leather bands that were held together by richly colored strapping and cords. For the Creagal, I chose to use a color triad of Olive Green, Cobalt Blue Hue and Cadmium Orange Light.

TECHNIQUE

SCALE MAIL

Scale mail is comprised of rows of overlapping metal scales that resemble fish scales. In fact, when painting scale mail, fish scales make an excellent reference.

1 Begin with a Burnt Umber and Titanium White underpainting, using crisscrossing diagonal lines of Burnt Umber to indicate the shadows cast by the overlapping metal.

2 The shadow lines where the light is brightest on the mail should be much lighter than in the halftone and shadow areas.

3 Paint in Titanium White highlights on the brightest scales.

4 Apply transparent layers (glazes) of a gray mixture of your choosing.

5 Finally, go back in and reestablish the highlights.

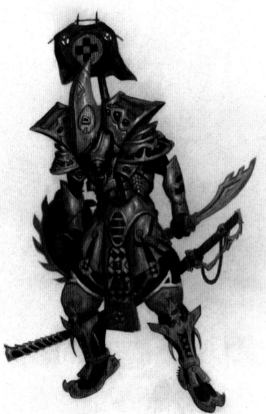

3 The majority of the metal on the Creagal will be silver, with some gold accents. Silver can be achieved easily by adding thin layers of cool grays on top of your underpainting, then adding some Titanium White into these wet layers to create the highlights. Highlights on all materials can be achieved by painting lighter hued colors on top of the bases. For example, build up the highlights on the areas of dried Olive Green by painting Chromium Oxide Green, Cerulean Blue and Raw Sienna directly into each other.

4 Use tonal adjustments to guide the viewer's eye. Create a smooth tonal transition from the center of interest to the outlying parts of his anatomy. We want the center of attention to be the Creagal's head; therefore, the highlights and midtones in his helmet should be much lighter than those at his feet. Causing the lower part of the Creagal to gradually move into shadow will lend the figure an ominous sense of mystery. Keep in mind that the light source is in the upper right of the image.

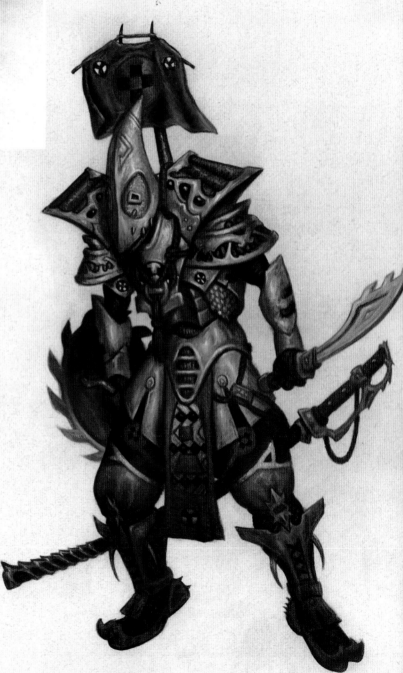

LICH

The lich is a creature so full of spite, hatred and determination, even death itself cannot stop it from its quest. The lich started out as a benevolent mage of great renown. As the great wizard began to age, his thoughts increasingly turned to regret for knowledge that would remain hidden. In his last peaceful days, the mage stumbled upon a passage in an ancient tome that hinted at a cure for aging. Eventually, the wizard became obsessed with lore and myth involving stories of extending life, mostly by unnatural acts. Through discovery and use of this arcane knowledge, the mage extended his life by decades. In his desire for immortal life, the mage became transformed: physically, emotionally and spiritually. A hatred for the living and lust for knowledge consumed all traces of his humanity. The mage achieved his goal: he defeated death and became a lich.

STAFF

LEG ARMOR

LICH CHARACTERISTICS

✠ It is rumored that the lich still has his lair where he keeps all of the knowledge he has acquired over the centuries.

✠ Any graveyard, cemetery or tomb becomes a sanctuary and stronghold for the lich, increasing his power and threat.

✠ The lich is human size.

✠ The lich's skin is gray and leathery, stretched tight over the remaining flesh and skeleton.

✠ The flesh has rotted away from orifices such as the mouth, exposing the teeth in an evil grin.

✠ The nose and ears have fallen off, and the eyes are sunken.

65

LEG ARMOR

1 This piece of armor looks a bit familiar. Could it be proof that the lich was once human, or is it merely an artifact taken from a tomb or grave? Start the drawing with a gesture to layout the basic forms such as the wedge shape or the square flaps that form the armor on the top of the foot.

2 Start to define the shapes that form the armor. Use a ruler to make sure that the different segments are the right size and space from each other. When using gesture sketching intuitively and correctly, the segments will be fairly accurate even before adding the measurement marks. Don't worry if yours don't quite work out this way yet; it takes practice.

3 Define the final shapes with heavier marks and shading. As these shapes come together, use an eraser to start removing unnecessary marks. Then, erase areas that will be light or highlighted in the finished drawing.

4 Use light and shadow along with the remnants of the gesture sketch to define the forms with shading. Create cast shadows and highlighted edges, keeping the light source in mind. There is an ambient light source directly overhead, and the orb creates a secondary light source. This step is what really gives the armor shape and definition.

5 Finish the light and shadow, and erase the stray guidelines and marks. Use marks that describe the different materials. Don't forget textures such as rust and the dents that give the armor its character.

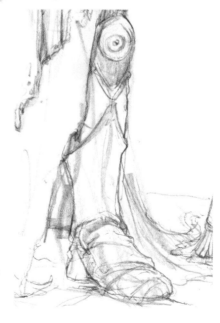

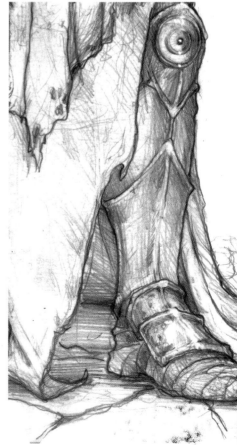

STAFF

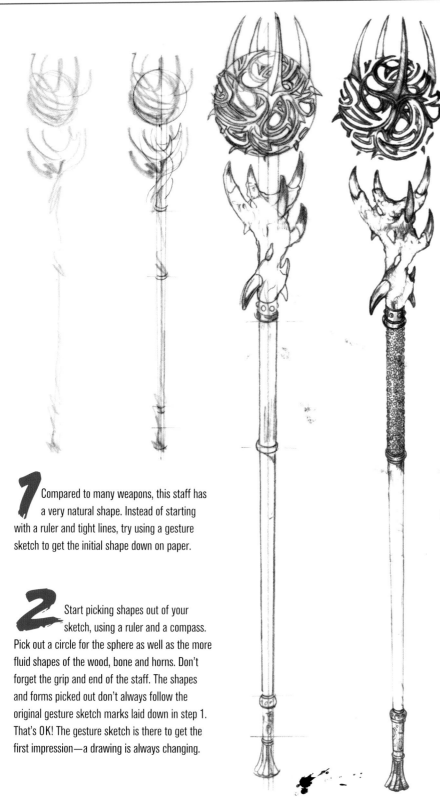

1 Compared to many weapons, this staff has a very natural shape. Instead of starting with a ruler and tight lines, try using a gesture sketch to get the initial shape down on paper.

2 Start picking shapes out of your sketch, using a ruler and a compass. Pick out a circle for the sphere as well as the more fluid shapes of the wood, bone and horns. Don't forget the grip and end of the staff. The shapes and forms picked out don't always follow the original gesture sketch marks laid down in step 1. That's OK! The gesture sketch is there to get the first impression—a drawing is always changing.

LICH WEAPONRY

- The lich's arsenal includes cast spells and weapons imbued with dark magic.

- The lich's most disturbing and twisted power is his ability to raise the dead, turning his victims into a mindless army.

- The sphere on the end of the lich's staff is not just floating by magic; it can be used as a projectile weapon.

3 When finalizing the shapes, think about what the weapon is made of and what it will be used for. This staff is made out of organic materials, such as wood, bone and horn, as well as metal. The ball at the top is made of metal, but it incorporates the shapes of natural vines and thorns. Erase any extra lines or marks.

4 Work on the texture so that all of the various materials start to take on their own unique characteristics. I looked at alligator skin for inspiration for the grip area; small circular shapes define the rough pattern and texture of the hide. You can even take this drawing further by adding magic effects like those that surround the sphere of the staff in the painting of the lich (see page 65).

DRAWING DEMONSTRATION

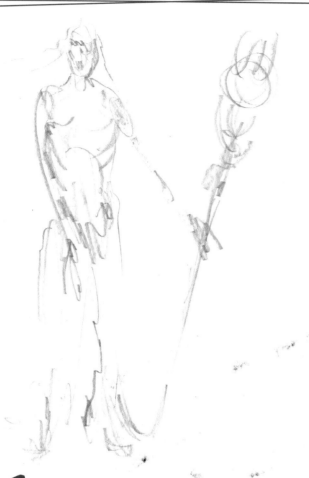

1 Begin with a gesture sketch. Using gesture sketches can help establish correct proportions and scale. All of the main parts of the figure's anatomy should be included. Already you can start to get a feel for his nasty staff and head. This gesture sketch will also be useful in establishing light and shadow. The sphere of the staff will be the light source.

2 Pick out some of the areas from the gesture sketch that are more in shadow and start to put them in, using broader shading marks. Using the marks from the initial sketch as guides, place the eyes, nose and mouth. Start defining some of the bigger shapes and forms like the rib cage, arms and clothing. Look at reference material such as a model, photo or magazine, or look at yourself in a mirror to help with placing these shapes and forms.

TECHNIQUE

TATTERED CLOTH

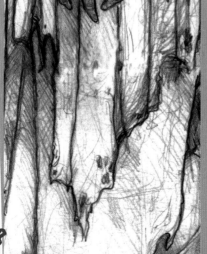

1 First get the folds of the cloth hanging so that they look natural.

2 Then look for areas that would be the first to get worn. Edges of cloth or areas that rub against something else are a good place to start.

3 Make small marks, usually in small groupings, to indicate worn or torn areas.

4 Use an eraser (plastic stick or kneaded) to make lighter areas on the outside edges of these marks to give them depth.

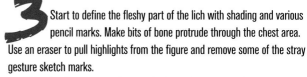

3 Start to define the fleshy part of the lich with shading and various pencil marks. Make bits of bone protrude through the chest area. Use an eraser to pull highlights from the figure and remove some of the stray gesture sketch marks.

Make the skin appear to be stretched over the body. Think about how the human skeleton would look tightly covered in leather. The eyes are visible in the deep recesses of the sockets. Using shadow above and below the eye will help you make them recede. The teeth are bared in a gruesome grin as the skin and lips recede. Look at your teeth in a mirror with your lips open as wide as you can make them for reference.

4 Use light and shading not only to define the shapes of things but to create a dark and somber mood. You can add to this mood by making magic light emanate from the sphere of the staff. Maybe wispy smoke with a light emanating from the center (pulled out with an eraser) will be the type of magic your lich is casting. This undead creature is ready to haunt the night. Keep the basic shapes in mind when shading areas such as the limbs. For example, the arm is basically a cylinder, so create a highlight on the biceps while rounding the form off with a core shadow on the triceps.

TROLL

Trolls are nasty and cruel beings, not very bright but extraordinarily cunning. Trolls have no political structure, social systems or codes. They are solitary creatures, living, hunting and surviving on instinct. They fashion their home from whatever the terrain and surroundings provide: a cave, a lean-to built from trees and branches or a hut built from mud. Trolls will carve out a territory and control it by any means necessary. A troll will fight and try to kill anything it deems a threat, regardless of the intruder's size or moral alignment. Occasionally, if the cause benefits the individual, trolls will join with others to engage in skirmishes against invading forces. These rare occasions of unity are just as likely to deteriorate into a fight among the trolls themselves, as it is to accomplish anything else.

HEADGEAR

ARM GUARD/ GOUGER

TROLL CHARACTERISTICS

✠ Trolls are around 8' (2.4m) tall and sinewy, all bone and muscle.

✠ Their flesh can be almost any color, from a bluish white to almost coal black. This depends solely on the environment where they live.

✠ Wounds that would be fatal to other creatures will barely slow a troll.

✠ Trolls' blood congeals at a highly increased rate, so wounds appear to stop bleeding and start healing almost instantaneously. This ability is often misconstrued as an ability to regenerate.

✠ The troll's mouth is not unlike that of a shark. The gums and teeth protrude from the mouth, making the troll's bite a dangerous weapon.

TROLL SWORD

HEADGEAR

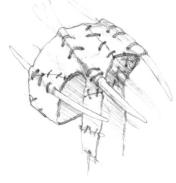

1 While the troll's headgear is primarily used for protection, it can be used as a weapon in close-up melee. Start by drawing a gesture sketch to find the overall form that fits the shape of the troll's head.

2 Pick out the shapes of the protruding, tusklike bones that jut forward from the head. Add the shape of straps that tie under the chin. These wrap under the head when worn by the troll, so they are long and almost rectangular in shape.

3 Refine the textures of the materials that form the headgear. The leather is softer than the bone, so the marks should also be softer as opposed to the longer, harder marks that create the look of bone. Create the sections of leather, along with the stitching that holds the pieces together. Use an eraser to make marks that help define the bones and the forms of the armor.

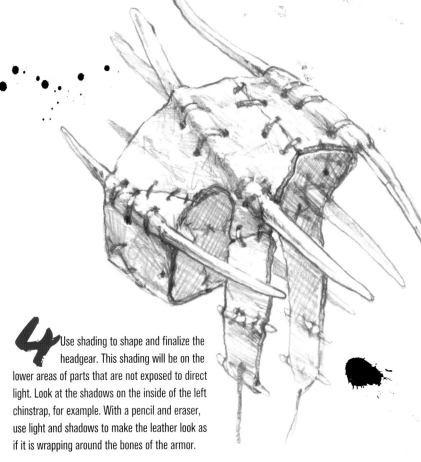

4 Use shading to shape and finalize the headgear. This shading will be on the lower areas of parts that are not exposed to direct light. Look at the shadows on the inside of the left chinstrap, for example. With a pencil and eraser, use light and shadows to make the leather look as if it is wrapping around the bones of the armor.

TROLL WEAPONRY

- Troll armor is crafted from found objects and the bone, flesh and hide of the dead, which has been boiled, grafted and reformed into organically-shaped, hideous pieces.

- Metal parts are kept sharp and rusted, making for nasty injuries.

- Trolls are constantly adding on to the weapons they carry, making them more and more deadly.

- Troll weaponry serves as a badge of honor and ranking system. All trolls recognize the weaponry of an experienced warrior and will keep off his territory.

- Trolls know how to use the land in warfare, building traps and larger weapons throughout their territory.

ARM GUARD/GOUGER

1 While it acts as armor and protects the arm, this dual weapon also works as a gouging and stabbing weapon. Like the sword, it is crafted from found objects such as scavenged weapons or bones. Start with a gesture sketch to find the overall shape that suggests its wicked functions.

2 Pick out and locate some of the vicious shapes, bones and the thin layer of flesh that helps hold it together. Emphasize the many jutting points and stabbing parts. Define the three main branches of the weapon as well as the stabbing ends and gouging tips.

3 Refine the textures of the primary materials: bone and leathery flesh. Add leather straps and buckles that hold the piece of armor to the troll's arm. These shapes are long, thin rectangles that look more handmade than the rest of the armor. Use an eraser to create marks that help define the bones.

4 Sketch the lines to make the edges of things, especially bony areas, look hard. Use shading and highlights to give volume and shape to the different parts, making this gooey mass of flesh and bone look like its been boiled and hardened. Now you have a useful and nasty tool for this killing machine to wield.

TECHNIQUE

BOILED ARMOR

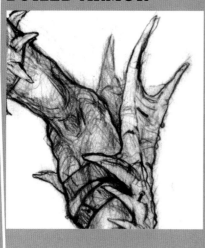

1 After the structure is established, think about what it would look like to stretch thick material between and around the bones.

2 Make fairly straight lines between the solid, bony areas.

3 Add shading around the lines to make them more deep set.

4 Use an eraser in points between the lines to make highlights that give the ridges volume.

TROLL SWORD

1 A troll sword is a savage weapon made of found objects such as scavenged weapons or bones of fallen foes. Start with a gesture sketch to find the shape and nasty jagged bits.

2 Pick out and define some of the shapes and parts in the gesture sketch. This sword has many points and stabbing parts. Begin to emphasize two main branches of the weapon as well as a grip area.

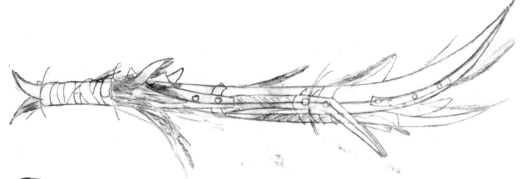

3 Start to define the materials that the sword has been cobbled together with: bone, metal, horn, leather, anything and everything. Bone is relatively smooth with small pits in it, while horn has rough grooves in it that either run the length of the horn or wrap around it to create segments. Make metal straps, studs, rivets and banding to hold it all together. Erase any extraneous marks and lines. If there's a shape you don't like, erase it.

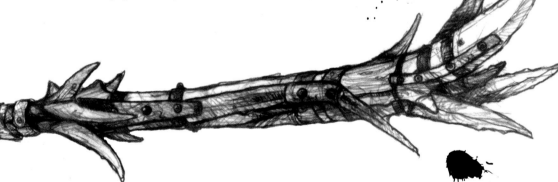

4 Use shading to finalize the shapes. Shading helps define volume, and it distinguishes the multitude of materials you've used to create this wicked sword. To get the shading in the correct spots remember where the light source is located. In this drawing, it is above the sword.

PAINTING DEMONSTRATION

1 I like to start from a medium-toned ground for two reasons: First, it knocks back the brightness of the white surface. This makes it easier to paint lighter and darker areas in the painting. The second reason is that I can affect the final painting's tone and look through this color choice. I wanted the skin to be green with a bit of a glow, so I used Naples Yellow Italian for the ground color.

After the ground color is dry, start to build up the forms, establishing the light and shadow. Apply thin washes of Burnt Umber. Start with the darker areas and build to the lighter areas of Naples Yellow Italian. Use thinner washes of Burnt Umber to transition between the colors.

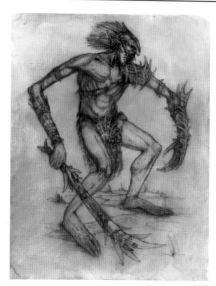

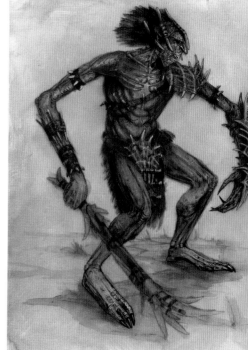

3 For the flesh areas, use Chromium Oxide Green, Olive Green and Prussian Green. Use Burnt Sienna, Raw Umber, Raw Sienna, Indian Red and Burnt Umber for the armor. Pick out the areas of thinner skin with Yellow Ochre. Areas with more blood, around the nose, cheeks and ears, should have a bit of Vermilion. Use a warm gray mixture made with Titanium White, Ivory Black and a touch of Burnt Umber and Olive Green for the bone parts. Make a cool gray with Titanium White, Ivory Black and Naples Yellow Italian. Use this mixture along with Payne's Gray and Burnt Umber for the metal sections. Pay attention to the shades in the metal, using Indian Red and Burnt Sienna to give it a rusty, battered feel. Continue to work on building up the lighter areas of the troll's armor using lighter versions of colors you used earlier. Keep building the surface of the shadows with Burnt Umber (mix in a touch of Payne's Gray to make it darker if necessary) and Burnt Sienna. Use a lot of Liquin mixed with Titanium White to paint the background white. I like to use smaller flats and angled shaders in close to the figure and larger brushes the farther out toward the edges of the painting I go. Let little bits of the Naples Yellow Italian underpainting show through.

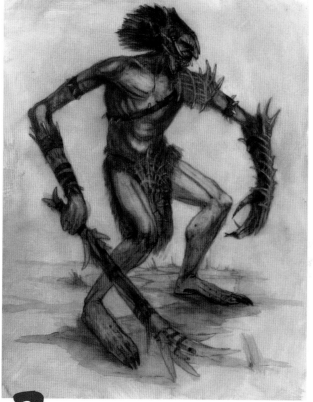

2 Mix a medium cool gray with Ivory Black, Titanium White and a touch of Cobalt Blue. Paint the flesh with the cool gray mixture, Titanium White and a little Ivory Black. Give the flesh more detail and built-up surface. Add details such as scars and warts. Continue to work on, and tighten up, the other areas of the figure. Use a little Ivory Black and Burnt Umber in shadows, Naples Yellow Italian in the light areas, and blend Yellow Ochre with Burnt Umber for midtone areas.

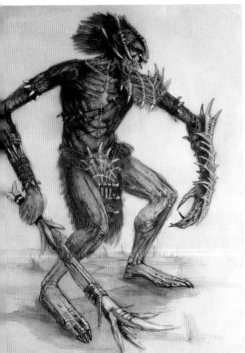

4 Make two off-white mixtures, one with Titanium White and a tiny bit of Yellow Ochre, and the other with Titanium White and a tiny bit of Burnt Umber. Use Yellow Ochre and the off-whites to define the bone parts of the weaponry. These colors give the surface its mottled, stringy leather look. For these parts, I thought about how pieces of meat that still have bones attached might look after sitting out for a few days. Bring the hair of the troll closer to completion with washes of the dark greens you used for the flesh in step 3 and Payne's Gray. For the fur of his clothing, apply washes of Burnt Umber with a touch of Payne's Gray mixed. Then, use thicker amounts of Yellow Ochre and Burnt Sienna, both full strength and lightened with Titanium White to give texture to the fur. Finish the darker areas, including the armor and other items the troll is wearing, with washes of Burnt Sienna. Apply the washes over the dry areas from the last step. Apply Naples Yellow Italian and Indian Red to the battle scars and warts that you created in step 2 to give them an infected, scarlike look.

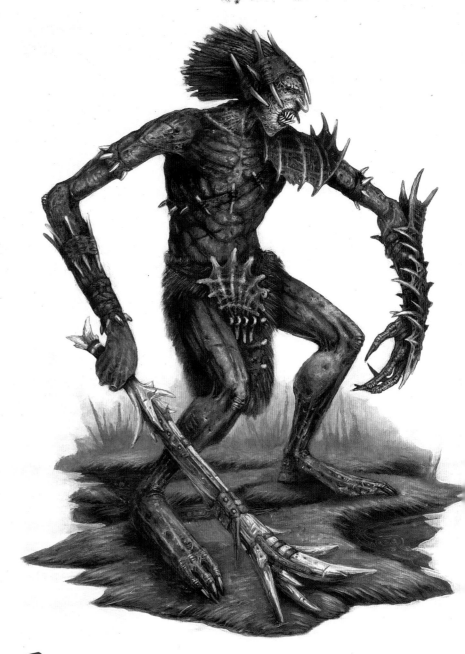

5 Use the greens and yellows from the previous steps to create the marsh. Add Burnt Umber along with a mixture of Burnt Umber and Olive Green to the water areas. Don't forget the shadow cast on the ground by the troll. Use Naples Yellow Italian to create the highlights on the grass. Add the highlights to finish the troll. Use mixtures of Yellow Ochre and Titanium White or Vermilion and Titanium White. For the hair, apply a mixture of Olive Green, Naples Yellow Italian and Titanium White. Apply mixtures of Titanium White and Olive Green, and Titanium White and Naples Yellow Italian separately. The armor highlights are Titanium White, Yellow Ochre and Indian Red (applied separately). Use an off-white mixture of Titanium White, a tiny amount of Burnt Umber and Payne's Gray for the weapon. The leather highlights are the warm gray from step 3. The troll is ready for battle!

The Iraxus, once a peaceful nomadic tribe that wandered the plains of Gorsalen, are now a bitter warlike horde with tainted hearts and twisted minds. Hundreds of years ago, the tribal chieftain Kalbax IX had the unfortunate luck of leading his tribe in a time of terrible hardship caused by a series of devastating blizzards.

On a spiritual quest, Kalbax set off alone into the mountains of Yerral. Frozen with sweat and delusional from hunger, Kalbax had nearly attained the peak when he came upon a tawny owl with eyes like pearls. The owl swooped down onto Kalbax and dropped a small seed into his palm. Perched on his shoulder, the owl whispered to Kalbax, "With this seed, save your people."

On Kalbax's return, the tribe decided to plant the seed, despite the harsh conditions. Miraculously, a tree sprouted and grew high into the air in a matter of weeks. The tree bore fruit with a pearly sheen, which provided much needed nourishment. The tribe gave up their nomadic ways and began to develop a settlement around the tree, which was now more than 200' (61m) tall.

All was well when the pearly-eyed tawny owl came and nested in the top of the tree. The town was overjoyed, and the fruit seemed sweeter than ever, but slowly the Iraxus began to change. Small disagreements turned into full-scale brawls. Eventually, the Iraxus became warmongers, building huge war machines to lead brutal campaigns against neighboring civilizations.

The tree that had once been the beacon of hope for the Iraxus was now seen as a beacon of despair to the rest of the world, and the fruit from that tree became known far and wide as the *pearls of hatred*.

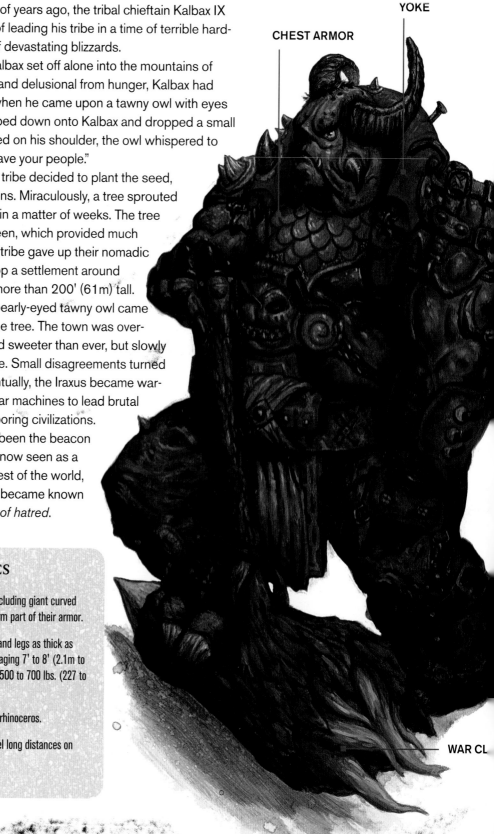

CHEST ARMOR

YOKE

WAR CL

IRAXUS CHARACTERISTICS

✠ Iraxus have many bull-like characteristics, including giant curved horns on their heads and giant yokes that form part of their armor.

✠ Iraxus usually have barrel chests, huge guts and legs as thick as tree trunks. They are thick with muscle, averaging 7' to 8' (2.1m to 2.4m) in height and weighing an astounding 500 to 700 lbs. (227 to 318kg).

✠ Their hide is thick like that of an elephant or rhinoceros.

✠ They have tremendous stamina and can travel long distances on foot, fully armed, without tiring.

CHEST ARMOR

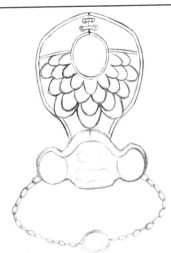

1 This piece of armor is comprised of several different elements. An underlayment of mesh covers the chest and shoulder connects at the back of the neck. On top of the mesh, several overlapping layers of scale mail are concentrated around the chest. An ornate metal crest rests at the base of the chest with a connecting chain that wraps around the Iraxus's midsection. Draw the basic shapes for all of these elements first before getting too caught up in the details.

2 At the inner and outer edges of the mesh layer, draw inset lines that follow the contour of the shape to establish the leather edging. Add two small leather straps to secure the armor at the back of the neck. The scale mail needs to radiate out from the neckline toward the bottom of the chest. Draw a row of connected inverted arches around the neckline. Then, draw successively larger rows of the same shapes.

3 For the ornamental crest, combine a bestial design with some geometric, yet organic shapes. First, draw a set of large curving horns at the top of the shape. Following the natural line of the horns, pencil in two circular shapes on either side. Pencil in the facial features of a bizarre creature, featuring an oversized mouth. Rough in the chain links that wrap around the Iraxus and the latch piece that connects them.

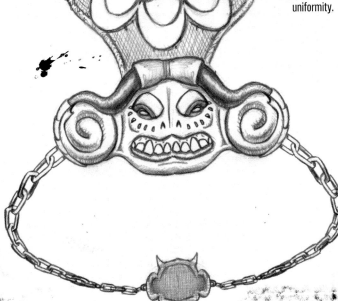

4 Use crosshatching to add texture to the mesh layer. Mark up the leather to make it look worn and cracked. Add shadows to the inside edge of the scales to create thickness. Inlay the circular areas of the crest with a spiral design. Form thick metal lids over the eyes and fill in the mouth with a set of giant teeth, making only the lowers visible. Add decorative flourishes around the eyes and at the ends of the horns. Finally, draw in the chain links, and make the latch similar in design to the crest for the sake of uniformity.

TIPS

- Keep good animal photo references on hand. Look at the different varieties of horns, hide and animal forms.

- Make the weapons out of less refined and natural materials such as wood, rough iron and leather.

- The use of exaggeration is important when drawing a creature like the Iraxus. Limbs should seem overly thick and weapons overly large.

- The Iraxus is mean and brutal. Get mad while drawing! Hippies don't come up with things like the Iraxus.

YOKE

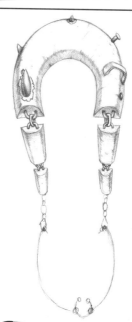

1 The Iraxus has many traits in common with the ox, so a yoke is an appropriate piece of neck armor. It also symbolizes their slavery to the pearls of hatred. The yoke wraps around in a U-shape. It breaks up into smaller segments connected by chain to allow for maneuverability. A rope wraps around the back, secured by a large metal ring.

2 The yoke is thick, so lightly pencil in lines within your initial shape to indicate where the form turns to create three-dimensionality. Do this to all the wooden segments of the yoke. Rough in some links of chain to connect the rope to the yoke. Transform the connecting ring in the back into a horseshoe shape with round metal caps at its ends.

3 Roughly shade the yoke from the lines that you drew in step 2 to the edge of the shape. Make marks that run perpendicular (at 90 degrees) to the contour of the yoke to act as splits in the wood. Add a variety of other marks such as small ovals and tightly spaced hatch marks to show areas of wear and damage. Finally, add some spikes, large iron nails and a metal loop to the main body of the yoke. The spikes will add some offensive capabilities, and the nails and loop will reference the traditional use of the yoke.

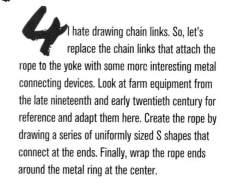

4 I hate drawing chain links. So, let's replace the chain links that attach the rope to the yoke with some morc interesting metal connecting devices. Look at farm equipment from the late nineteenth and early twentieth century for reference and adapt them here. Create the rope by drawing a series of uniformly sized S shapes that connect at the ends. Finally, wrap the rope ends around the metal ring at the center.

WAR CLUB

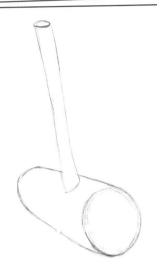

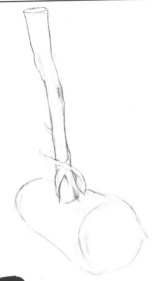

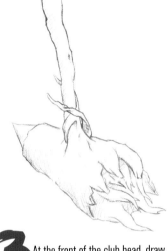

1 Stick to simple shapes during the first step. The head of the club should be huge. A large cylinder shape will work well here. Halfway along the length of this cylinder, draw a much narrower and longer cylinder rising straight up to form the handle.

2 The head is formed from a tree trunk, while the handle is a large branch. Replace the straight lines of the club head with curving, organic lines. Make the handle narrower in some spots and wider in others with bumps and knots along its length. Add some twisting vinelike growths at the joint between the handle and the head for reinforcement.

3 At the front of the club head, draw a variety of twisting roots that have been sharpened into points protruding from a ring of thick, rough, jagged tree bark. This will be ideal for rending the flesh from bones and shattering the spines of foes. Make the fibrous inner wood of the tree extend out past the bark at the back of the head, forming a large spike capable of impaling victims with one mighty blow.

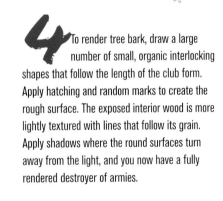

4 To render tree bark, draw a large number of small, organic interlocking shapes that follow the length of the club form. Apply hatching and random marks to create the rough surface. The exposed interior wood is more lightly textured with lines that follow its grain. Apply shadows where the round surfaces turn away from the light, and you now have a fully rendered destroyer of armies.

DRAWING DEMONSTRATION

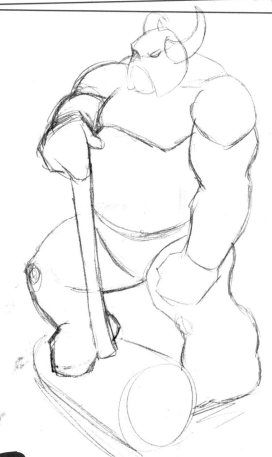

1 Begin with the most basic of techniques, the stick figure. We want to have an iconic three-quarter view with the camera looking down on the creature. Oval shapes indicate the location of the head and pelvis, with a sweeping line between the two representing the spine. A curving line running perpendicular to the spine just below the head is used as a guide for the collarbone, which ties the creature's shoulders together. The arms and legs are curving lines emanating from the shoulders and pelvis, respectively, with small circular indications for elbows and knees. Its right foot and hand rest on the battle hammer.

2 Now, flesh out the shapes of the Iraxus. The key word is *thick*. It has a large barrel chest and expansive gut as a base for its boulder-sized shoulders and massive arms. Its legs are thick and densely muscled, and stubby like a rhinoceros's. Its head is relatively small in proportion to its body, making it seem even more gigantic. Roughly indicate the features of the head. A down-turned mouth with jowls like a bulldog, a flattened nose and twisted horns give the Iraxus the character we are looking for.

TECHNIQUE

LEATHERY HIDE

1 Begin by looking at photos of rhinos and elephants.

2 Attack your drawing with a variety of strokes; from rapid back-and-forth movements with the side of your pencil lead to more precise hatch marks with the sharpened tip.

3 Fill its hide with ridges and wrinkles, while allowing some of the areas to be smoother to create an interesting contrast.

STICK TO THE BASICS

The stick figure is a favorite mode of representing the human form among children worldwide. Taken one step further, with simple indicators for joints and structures such as the pelvis, hands and feet, the stick figure is highly effective for quickly nailing down a pose.

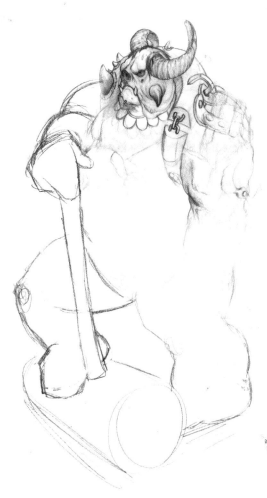

3 Begin to add all the details that will make the Iraxus unique among beasts. Base its hide on that of the rhinoceros, thick and platelike, with deep grooves and folds in the flesh. Tufts of coarse black hair sprout out at the base of the horns, and one thick short horn sprouts from its cheek. A heavy brow and protruding fangs give it a fierce visage. Finally, there should be little distinction in width between its calf and foot. To carry so much weight, it has to be one thick unit, like a tree trunk.

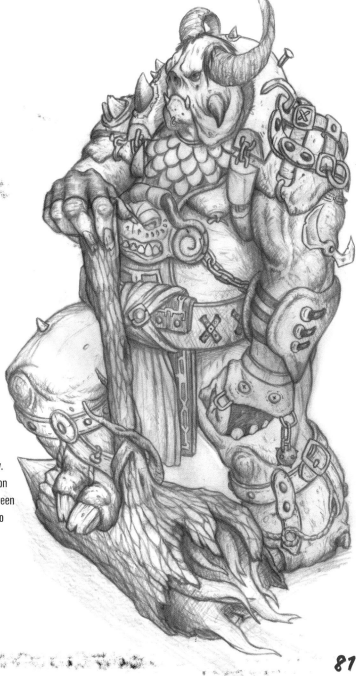

4 In addition to the items described in the preceding demos, give the Iraxus a wide variety of armor pieces. Leather straps with buckles, metal rings and hooks crisscross its shoulders and shins and run through the deep crevices of its thick rhinolike hide.

A pinwheel of blades is bolted directly into the flesh above its left elbow. Gloves, bracers, belt and loincloth should be designed to express a civilization with its own unique imagery and iconography. Look at the differences between the visual themes of ancient cultures like the Aztecs, Egyptians and Norse to get a firm grasp of this concept.

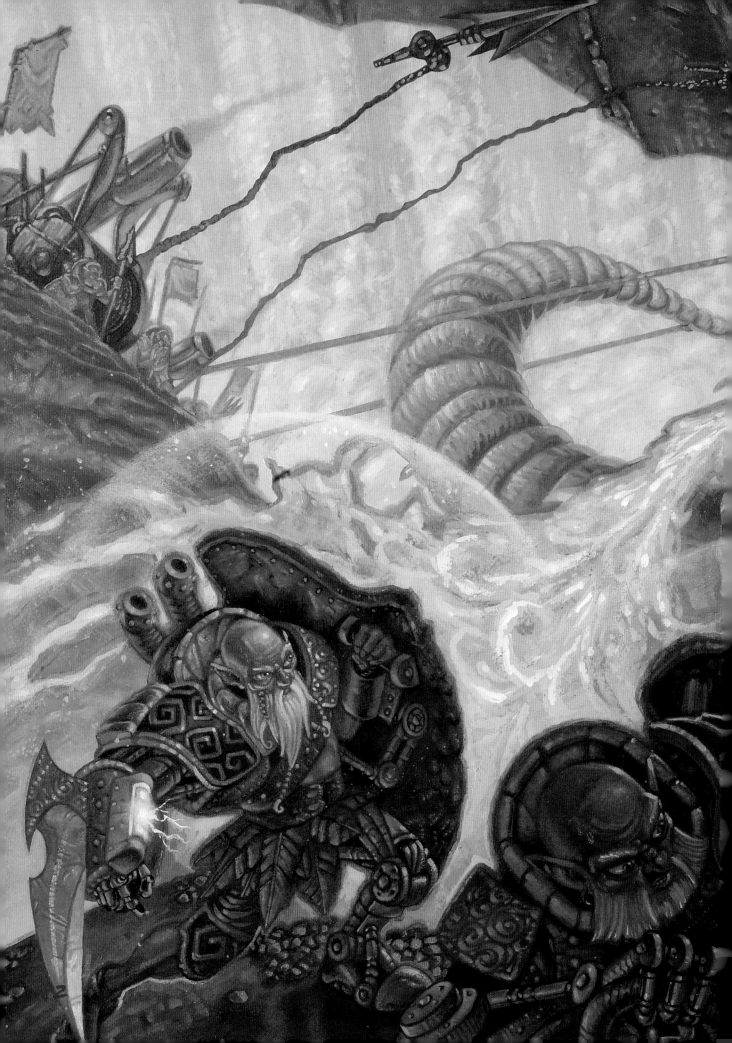

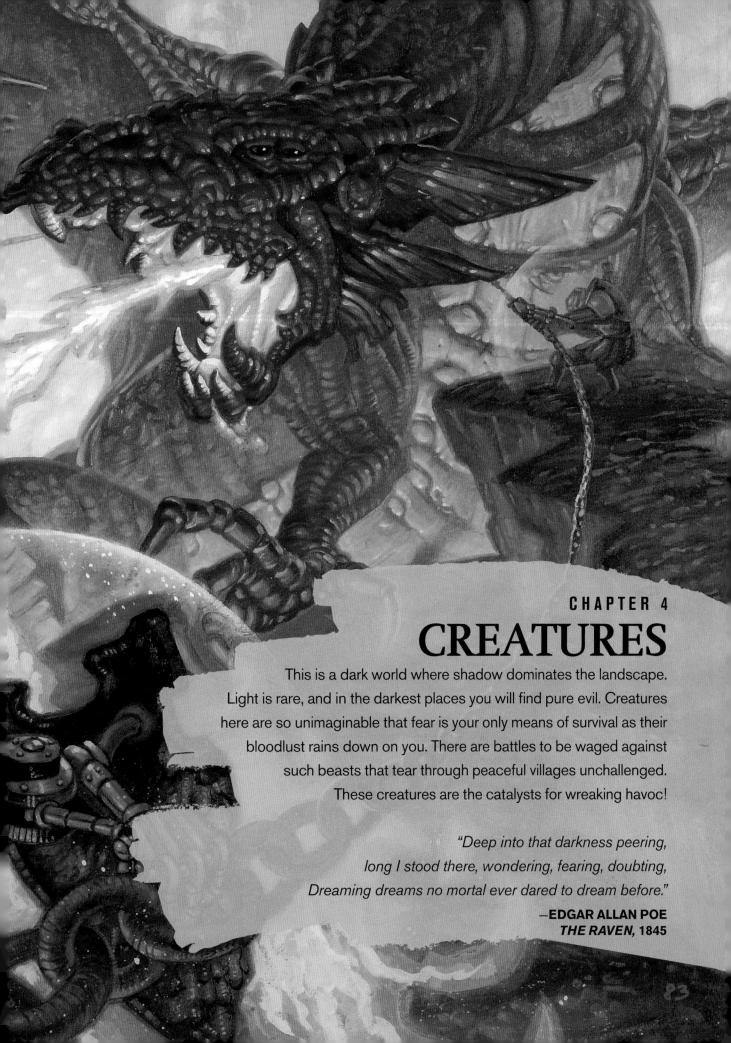

CREATURES

This is a dark world where shadow dominates the landscape. Light is rare, and in the darkest places you will find pure evil. Creatures here are so unimaginable that fear is your only means of survival as their bloodlust rains down on you. There are battles to be waged against such beasts that tear through peaceful villages unchallenged. These creatures are the catalysts for wreaking havoc!

"Deep into that darkness peering,
long I stood there, wondering, fearing, doubting,
Dreaming dreams no mortal ever dared to dream before."

—EDGAR ALLAN POE
THE RAVEN, 1845

DRAGON

Dragons are arguably the single most popular mythological creatures ever created, so I take their design very seriously. World mythology has supplied us with infinitely diverse descriptions, but there are some cultural standards that I like to follow.

Western dragons generally represent the time before humanity as we know it and live inside mountains or are the mountains themselves. The Western dragon breathes fire or acid, has vast wings attached to its torso, hoards treasure and is often seen as a menace.

The Eastern dragon doesn't have wings. It has a long bellows, running from a hole in its head to its tail, that shoots it through the air. Eastern dragons often breathe fire, but their claws are a more powerful weapon, and sometimes you'll find them with five or six legs. Although dragons hoard their "Pearls of Wisdom," emperors have been known to steal from them, and these rulers rely on the dragon's benevolent nature for advice.

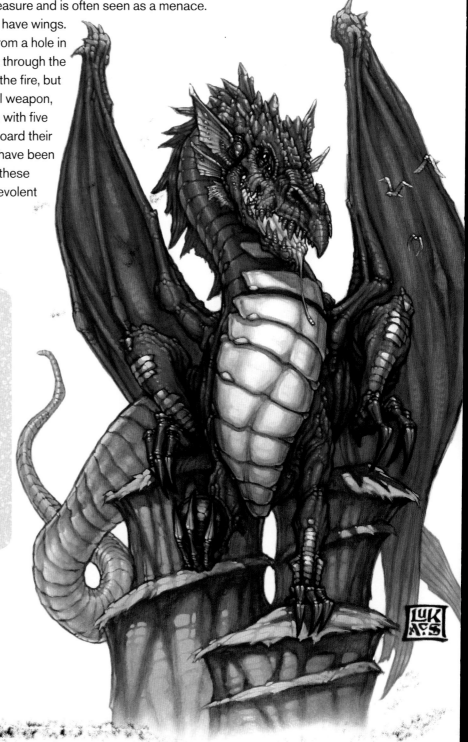

DRAGON CHARACTERISTICS

Although dragons are generally large and reptilian and clearly influenced by dinosaurs, their anatomy can be derived from a number of different animals. This list is a good starting point:

✠ HEAD AND HORNS: crocodiles, snakes, bulls and deer.

✠ TORSO: crocodiles, snakes, bulls and horses.

✠ WINGS: bats and membrane wings.

✠ LEGS AND TALONS: birds of prey, big cats, lizards and frogs.

DRAGON ARMOR

1 Sketch out the major shapes of the face, and plot a centerline through the head and neck. Use different elements of crocodile and Tyrannosaurus rex skull anatomies.

2 Add the ears and start detailing the jaw lines with teeth. The skin should show a bit of the coarseness and major lines of the skull underneath.

3 Add more detail to the ears, the teeth and the skin around the orbits of the multiple lids and eyes. Leave space in the gums for the larger teeth. This gives the impression that those jaws could fit right together when closed.

4 Finish your dragon with the crown of wrinkles and scales along the forehead following the centerline. Darken the outlines, erase the spot highlights, and your dragon is ready to take a bite out of its next meal.

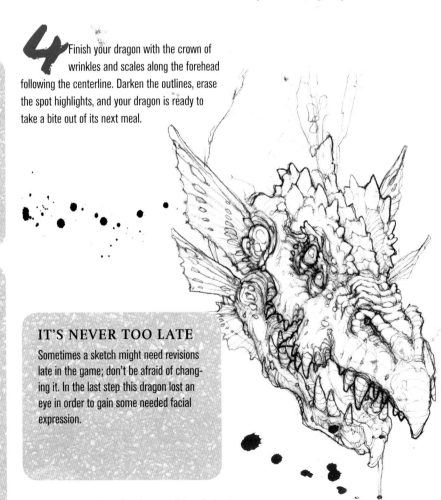

NATURAL WEAPONS

There's no good reason why you can't give dragons additional armor and weapons, but most of the time they're described as having what nature alone has given them. Their horns, plates and scales act as armor, and their fiery breath, claws and tail act as offensive weapons.

DRAGON ARMOR: SKIN AND SCALES

There's a loose science to skin and scales. Snake and tree frog patterns hold the same sort of random, segmented shapes, and studying more about how skin and scales grow will help you sketch them.

IT'S NEVER TOO LATE

Sometimes a sketch might need revisions late in the game; don't be afraid of changing it. In the last step this dragon lost an eye in order to gain some needed facial expression.

DRAGON FIRE

1 Begin with the basic shapes that form the neck and main features of the dragon, making a slight twist in the neck. Then play with the chaotic shapes that form the fire. This might take some erasing and resketching, but settle on something that looks believable.

2 Here we add specifics to the dragon: teeth, scales, eyelids and ears. This jaw structure is a mix of crocodile and Tyrannosaurus rex anatomy. You can take a lot of information directly from a good reference. This is especially helpful for the folds in the neck and the muscles that connect the upper and lower palate. When you sketch larger scales, think of them as warts or hair—apply them randomly.

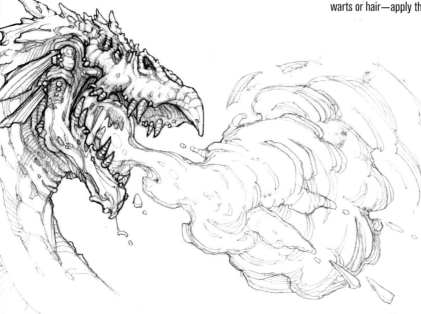

3 Tighten everything up. Outline the major shapes, while adding shadows, and erase highlights to make the forms more three-dimensional. Remember to treat fire or magic as an additional light source that will create a whole new range of reflective light.

LISTEN CLOSELY: EAR ADVICE

Notice the ears have bent down to close when our dragon fires off her breath. This is a reflex reaction that you'll see animals do to protect themselves. It's like closing your eyes when you sneeze.

FIRE

It's the fantasy artist's job to capture real-life moments and assemble them into something that's impossible, but believable. Here are some tips for drawing realistic fire:

1 Think about what your breath looks like in cold weather. The vapor forms chaotic smokelike waves and eddies as it's blown outward.

2 Look at a campfire or the smoke from incense (or pictures of both). Watching how smoke moves and flows will help in creating believable dragon breath.

3 Look at photos of fire and explosions. You'll notice that the heat almost instantaneously starts to rise straight up. Create a chaotic stream of fire, keeping in mind the direction it's shooting and how the smoke will rise.

PAINTING DEMONSTRATION

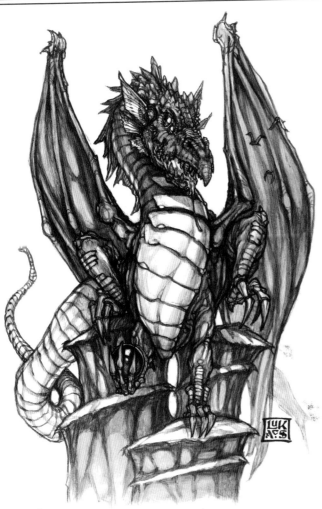

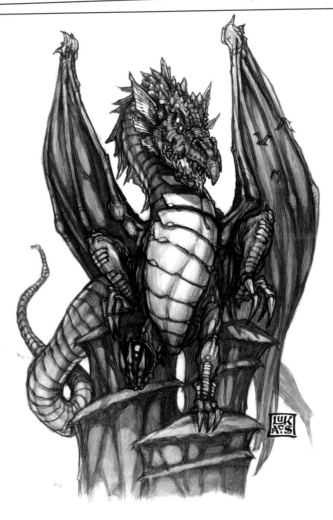

1 Add some tone throughout the whole character, but keep the chest plates fairly white. Create some interesting line work, drawing with the brush as you would a pencil. Start your acrylic wash of Burnt Sienna and Burnt Umber, defining the lights and darks, fading off the tips of the wings and tail to create a greater sense of depth.

2 Next, map out all the major color groups with transparent oil washes. Grouping this painting is a bit more difficult. In many areas one transparent color fades into the next, like a rainbow. Keep each of these transparent colors free of alkyd drying medium, and keep them wet on your palette, as you'll need to blend into them in the next step. I broke the color down into these groups: (1) wing tips and tail (Magenta and Manganese Blue); (2) mountaintops (Burnt Umber, Burnt Sienna, Manganese Blue and Yellow Green); (3) head, legs and wings (Alizarin Crimson and Burnt Sienna); (4) white chest plates and leg scales (clear Liquin); (5) pearl and eyeballs (Ultramarine Blue and Burnt Umber); (6) glowing mouth (Alizarin Crimson, Transparent Yellow and Burnt Sienna).

REMINDER!
Each painting begins with a drawing. To create the drawing, look at the painting and copy the basic lines. Pay attention to shading and texture.

GRIN AND "BARE" IT
Wrinkles between the nostrils and brow line will make any creature look like it's growling or snarling.

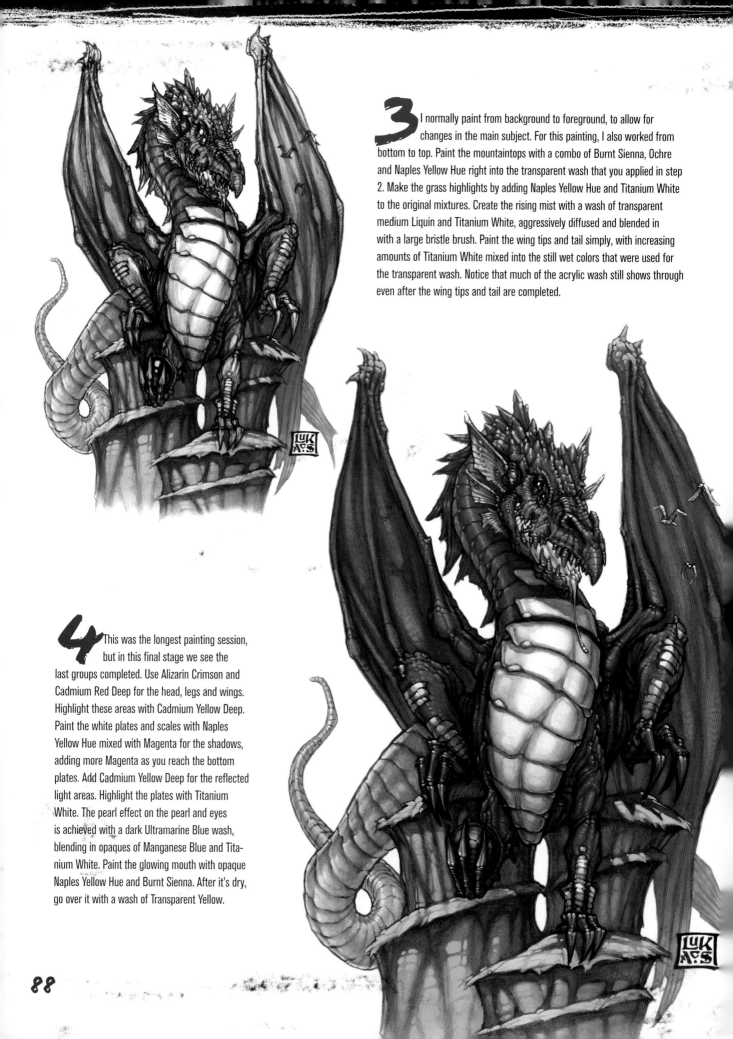

3 I normally paint from background to foreground, to allow for changes in the main subject. For this painting, I also worked from bottom to top. Paint the mountaintops with a combo of Burnt Sienna, Ochre and Naples Yellow Hue right into the transparent wash that you applied in step 2. Make the grass highlights by adding Naples Yellow Hue and Titanium White to the original mixtures. Create the rising mist with a wash of transparent medium Liquin and Titanium White, aggressively diffused and blended in with a large bristle brush. Paint the wing tips and tail simply, with increasing amounts of Titanium White mixed into the still wet colors that were used for the transparent wash. Notice that much of the acrylic wash still shows through even after the wing tips and tail are completed.

4 This was the longest painting session, but in this final stage we see the last groups completed. Use Alizarin Crimson and Cadmium Red Deep for the head, legs and wings. Highlight these areas with Cadmium Yellow Deep. Paint the white plates and scales with Naples Yellow Hue mixed with Magenta for the shadows, adding more Magenta as you reach the bottom plates. Add Cadmium Yellow Deep for the reflected light areas. Highlight the plates with Titanium White. The pearl effect on the pearl and eyes is achieved with a dark Ultramarine Blue wash, blending in opaques of Manganese Blue and Titanium White. Paint the glowing mouth with opaque Naples Yellow Hue and Burnt Sienna. After it's dry, go over it with a wash of Transparent Yellow.

GARGOYLE

A great beast roamed the Seine River valley in France in the early Middle Ages, spewing chaos along its path. This beast was called Gargouille. It laid waste to the city of Rouen, and was *supposedly* smote by St. Romans in the seventh century A.D. As an astute observer of all things unholy, I doubt the veracity of this account. One fact cannot be denied: the children of the Gargouille can be seen in legion throughout France, sitting atop the cities' magnificent gothic structures. During harsh rains their open maws spew water down upon the humans they hate so vehemently. At night, they break free of their perches with a thunderous crack and wreak havoc upon a wide host of victims. They are the gargoyles, and neither flesh nor bone can withstand their rage set in stone.

GARGOYLE CHARACTERISTICS

✠ Gargoyles can range in size from very small (about 1' [30cm] high) to very large (the largest reported gargoyle coming in at just over 12' [3.7m] high).

✠ They, and all of their weapons and equipment, are made of stone.

✠ Gargoyles have no heart or soul and are powered by elemental magic that is drawn from the earth.

✠ The combination of their stony structure and elemental powers make them almost impervious to normal physical attacks.

✠ Although they are made of stone, gargoyles can fly great distances through the use of elemental magic, with the stipulation that they are back on their perches before daybreak.

SHIELD

SWORD

SHHELD

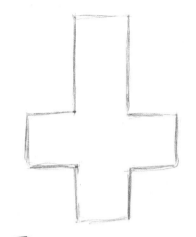

1 This gargoyle took an overturned headstone from a decrepit cemetery and fashioned it into a shield for itself. A cross-shaped headstone will tie in nicely with the gothic architecture on which the gargoyle is based. Start your design by drawing a simple cross, preferably inverted. This allows the longest arm of the cross to defend the area around the gargoyle's head.

2 Determine the height and width of the cross. A wider cross works better because it keeps to our design guideline of basic, sturdy weapons, and it works well for a defensive weapon. A thin, ornate cross would shatter too easily under the savage blows it will receive.

3 Finish the shape of the cross by adding the third dimension: depth. First choose the angle at which you want it to be viewed. In this case we are looking at it from slightly to the left and below the shield. Draw a series of diagonal lines to the desired length for the depth of the shield. Replicate the lines that form the left and bottom edges of the cross shape to close off the shield form.

TECHNIQUE

STONE

The key to drawing a stone texture is randomness, or more specifically, a lack of uniformity. The small ovals indicating embedded pebbles and surface holes and the lines indicating cracks and fissures need to be random and varied, in both placement and size. Nature is quite chaotic, and nothing will make something look more unnatural than evenly placed lines and uniformly sized and spaced shapes.

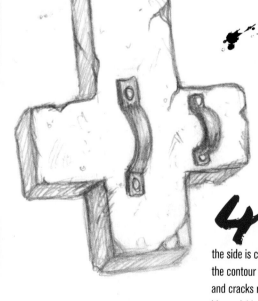

4 Shade the area you just drew so that the face of the shield is lit evenly and the side is cast in shadow. Create indentations in the contour of the cross shape to indicate chips and cracks received from combative weapon blows. Add randomly placed dots and small circles as well as areas of hatch marks to create the texture of stone. Finally, add some straps to the cross through which the gargoyle can secure a firm grip. The straps should be of uniform width. Their ends should attach to the shield with bolts, allowing enough slack for the gargoyle's hand and forearm to fit through

SWORD

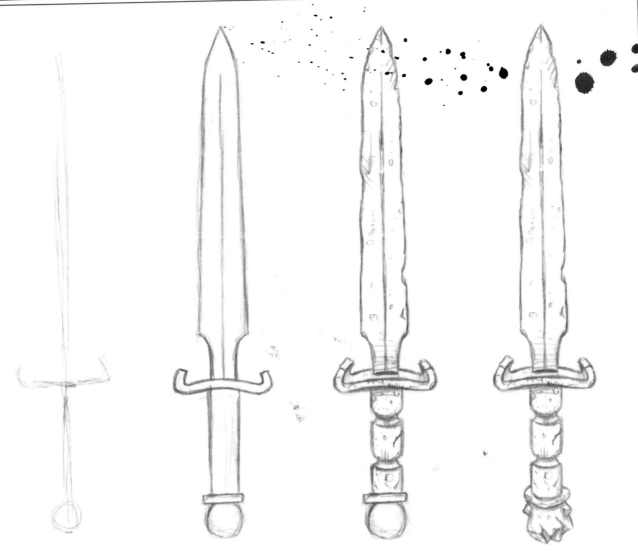

1 This sword is based on a simple medieval design. The blade is relatively short, and the hilt ends in a round cap (pommel). The cross guard should turn up slightly at the ends for trapping opponents' blades.

2 Add width to the initial design. Keep the blade design simple; the only variation in the edge of the blade is a curved indentation where the blade inserts into the hilt.

3 Now, render the sword as stone. Make the blade edge rough and chipped. Divide the hilt into three equal-sized segments with small grooves carved in between. This will allow for a stronger grip.

4 The pommel is the final touch. It should be a large jagged stone instead of the traditional ornamental disk. Now the gargoyle can use it to smash the bones of its enemies.

DRAWING DEMONSTRATION

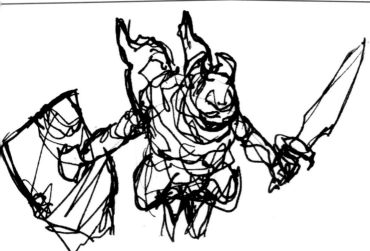

1 Use a ballpoint pen to make a loosely shaped drawing of the beast. I like the ballpoint pen for this stage of the design because it moves so fluidly over the page and allows freedom of movement for your arm. The gargoyle's shape should be compact and sturdy to emphasize its rocky structure. Draw the gargoyle as if it is still rooted to the side of a wall of a stone fortress. Rooted to the spot, its pose could become boring, so spread its arms wide to portray imminent action, and give the gargoyle a sword and shield to hold. Scan the ink rough into the computer and use image manipulation software to enlarge the image to a comfortable drawing size and to lighten the black lines. Then, print it out onto a nice piece of drawing paper. You now have a strong gesture sketch and shape design to begin refining and adding details to.

2 Hacking at a gargoyle with traditional weaponry would be literally like hacking away at a boulder. However, don't get lazy just because the gargoyle already has such a tremendous natural defensive system. Construct its shoulder structure out of overlapping layers of stone. Cover these with rows of sharp spikes that would be useful if the gargoyle charges and drives its shoulder into its enemy. Apply the same design to the head. Rows of spikes should run from its brow ridge to the top of its skull, while pointed teeth, more spikes and huge curling tusks radiate from its jaw. Now the gargoyle can use its head as an offensive juggernaut to tear and rip at its victims.

TIPS

- Don't feel restricted in your designs by the traditional architectural gargoyle.

- Let the fact that the gargoyle is made of stone impact your initial gesture drawing.

- A stony texture is simple to draw by adding small random circles and various hatch marks throughout the form.

- Sharply angled eyes and a wide-open mouth full of sharp teeth will make your gargoyle look evil and menacing (which is good).

ADVANCED MANEUVERS

Want to go a step further and paint? Choose colors you like and follow the basic procedures found on pages 10–11 or in any of the painting demonstrations.

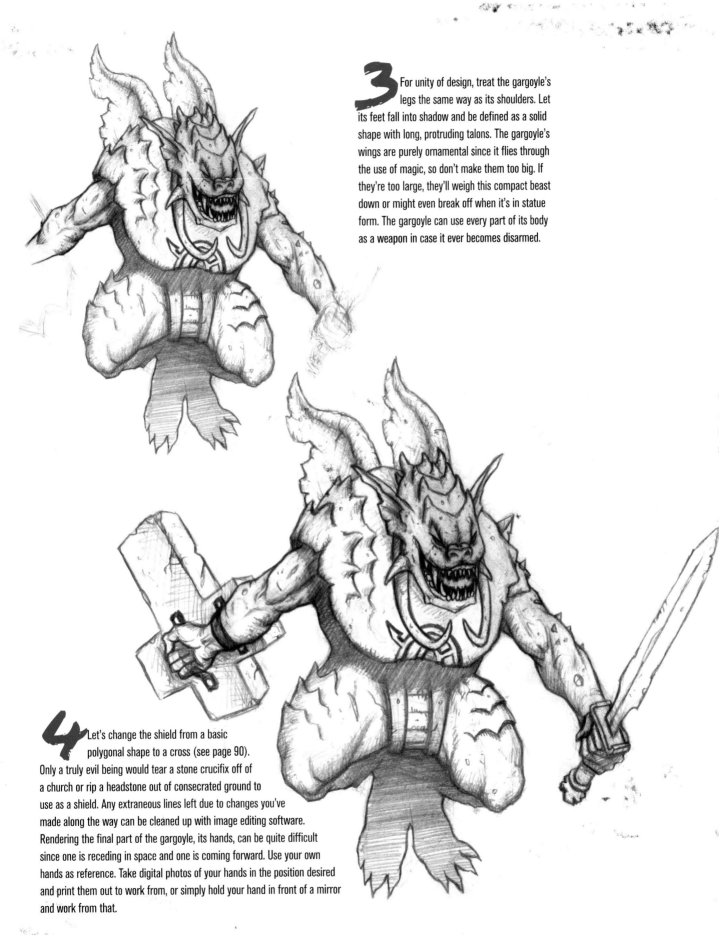

3 For unity of design, treat the gargoyle's legs the same way as its shoulders. Let its feet fall into shadow and be defined as a solid shape with long, protruding talons. The gargoyle's wings are purely ornamental since it flies through the use of magic, so don't make them too big. If they're too large, they'll weigh this compact beast down or might even break off when it's in statue form. The gargoyle can use every part of its body as a weapon in case it ever becomes disarmed.

4 Let's change the shield from a basic polygonal shape to a cross (see page 90). Only a truly evil being would tear a stone crucifix off of a church or rip a headstone out of consecrated ground to use as a shield. Any extraneous lines left due to changes you've made along the way can be cleaned up with image editing software. Rendering the final part of the gargoyle, its hands, can be quite difficult since one is receding in space and one is coming forward. Use your own hands as reference. Take digital photos of your hands in the position desired and print them out to work from, or simply hold your hand in front of a mirror and work from that.

OGRE

Unlike the standard unintelligent, primitive, solitary ogres you might be used to, the ogres you see here are intelligent, capable of highly complex thought and cunning strategy. They are slow to anger, but when roused are an almost unstoppable force of brute strength. Ogres maintain a highly developed society, living in towns with small populations in peaceful surroundings. They build fortifications that may seem large to a smaller creature like a human or dwarf but are modest in scale to the ogres themselves.

These ogres are an elder race predating humans and are keepers of knowledge and information forgotten, lost and even unknown to most of the other races. Not only is the race itself an old one, most ogres are long-lived in comparison to humans. Ogres are a noble race, with a full history of great warriors, learned scholars, artisans and craftsmen, and they are a great source of inspiration.

ARMOR

OGRE CHARACTERISTICS

✠ Ogres are massive, 12' to 14' (3.7m to 4.3m) tall, with arms and legs like tree trunks.

✠ Ogres' skin color is a golden-gray range from a light, almost gold, to a dark, brownish gray.

✠ Their hands, despite being huge, are quite nimble at making things.

✠ An ogre's face is generally kind looking. However, when angered, its large jaw and teeth become much more apparent.

MASSIVE HAMMER

ARMOR—FRONT VIEW

1 The ogre's armor is highly advanced; it is built to allow movement and will articulate with the ogre's every move. Using a ruler and circle-making tool, start with the vertical centerline, the horizontal line at the bottom of the shoulders and the circular shapes of the head guard and shoulders. Add the basic shapes of the straps and buckle that hold the armor together in the center. Grid in the area that will become the lower armor.

2 Begin to add to the circular shapes. Add the peak at the top of the head area, and define the thickness of the pieces of armor. Create this thickness by finding the appropriate width you want and adding lines that parallel the ones you have already made. Continue to define the shoulder armor, adding the general shape of the biceps guards. The belt takes shape here, as do the straps and buckle. Draw the straps as thick as you want, using the Y-shaped guides added in step 1. Using a template, make the belt an oval shape to give it depth in space. Make several overlapping vertical rows of triangles hang from the belt to define the lower armor.

3 Finalize the overall designs and shapes of the armor. Make cleaner, crisper lines with darker marks. Pay attention to how different parts overlap, such as the bands around the torso. Notice how each band looks as if it will slide under the one above it. Make changes to the parts as necessary. Clean up any stray marks, guides or measurement marks.

4 Add the dark shading and highlights to give the drawing its volume and density. Pay attention to the light source. In this drawing it is above the armor. Make sure areas like the edges of the shoulder guards are in shadow. Also, show cast shadows where parts overlap or are above other parts. Using marks and shading, make the different materials (steel, studs, leather and so on) look authentic. To make a stud look raised, first establish the shape (circle). The light is coming from above, so add shading to the bottom side of the stud, leaving the top white as if it is reflecting the light. Notice that I curved the shading down in the center of the armor to help with the illusion of volume. You can also add dents and scratches to the drawing of the armor to show that it gets plenty of use protecting the ogre from his opponents in battle.

ARMOR—SIDE VIEW

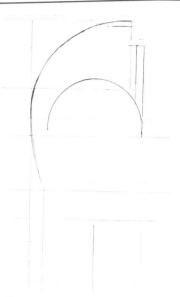
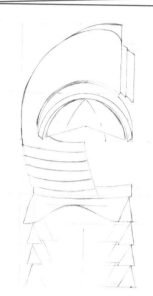
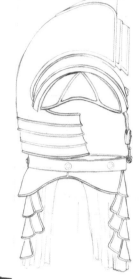

1 Use a ruler to find the vertical centerline. Then, find and measure the vertical lines that will mark the front and back of the armor. With a circle-making tool, map out the arch of the upper back and the curve of the shoulder. Continue to measure out the basic shapes of the lower armor, primarily using squares and rectangles to block in their locations.

2 Continue to define the armor. The neck pieces should overlap so that they can move in and out as the ogre's neck and head move. Begin adding the biceps guard's general shape and finish laying out the rest of the shoulder armor, paying attention to the thickness. Define the triangular shapes of the lower armor, along with the curved overlapping armor on the lower back and hips.

3 Finalize the overall designs and shapes by making the lines sharper with darker marks. Finish the ornamentation, including the studs and gold inlay along the edges of the separate segments. Add the belt in this step, along with the straps, buckle and cloth under the lower armor. Clean up any stray marks, guides or measurement marks.

4 Now, work on light and shadow. Establish where your light source is coming from; here it is from above. Put shading in areas where light doesn't hit and where things overlap. These elements allow you to show the mass and curves of the back's hump. The overlaps really show how the armor functions. Try to make the various materials read differently through your mark making. Imagine how intimidating this armor would be on the back of an ogre as he rumbled toward you.

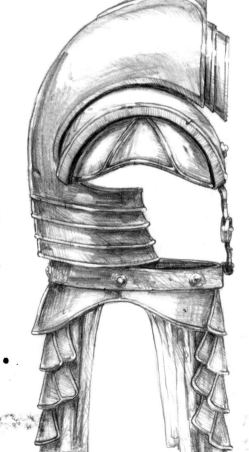

HAMMER

1 This hammer is massive! A human warrior would not be able to pick it up much less use it. Use a ruler and a circle-making tool to make the shapes symmetrical. Lay out the centerline, the length of the hammer's shaft as well as the head and position of the handle. For increased realism, make sure you use perspective to make the hammer sit in space. We are looking at this hammer from the lower left.

2 Begin to add circles, rectangles and triangles to form the ornamentation. Paying attention to the perspective you started in step 1, make sure the curves and shapes you add here are viewed from the same point.

3 Fine-tune the ornamentation and shapes of the hammer. Darken the lines at the edges of harder surfaces. This hammer has a lot of different planes and angles. You can use your marks to enhance these facets by making them directional. See how the marks on the top of the hammer head all run around the sides and down the handle? This helps define that surface spatially. You also need to start shading at this stage, paying particular attention to the perspective you have been using throughout the drawing. Areas that recede from the light source will be much darker than those that are closer, such as the bottom of the hammer's head.

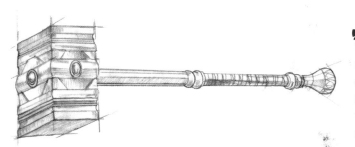

4 Clean up the drawing, erasing extraneous marks left from earlier stages. Using marks and shading, make the different materials (gems, steel, leather, etc.) look correct. Make the drawing marks softer in the area of the handle that is wrapped in leather. The metal areas higher in the handle or in the head itself should have harder marks that are more solid and rough. You can also add nicks and scratches to the drawing to let everyone know that the hammer is for more than just show!

PAINTING DEMONSTRATION

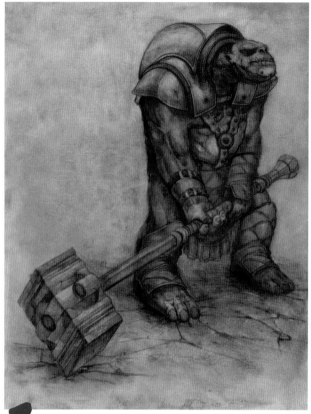

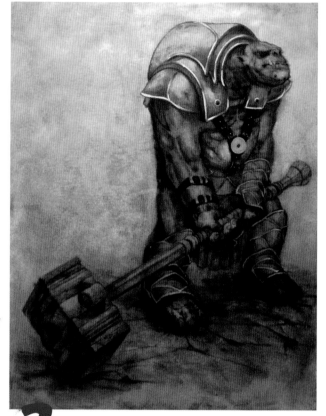

1 Start with a medium tone ground (I chose Indian Red). Paint the ground in light, thin washes, using turpentine for oil paint or plain water for acrylic paint. With oils or acrylics, use very small amounts of the mixture, and use a dry rag to wipe it down and smooth it out a bit. After this ground color is dry, do a tonal painting of the figure in thin washes of Burnt Umber to help establish light, shadow and form. Use a much darker wash for the darkest areas, a medium wash for a midtone and a wash with almost no color mixed in for the lightest areas.

2 Let the painting dry completely. Introduce Payne's Gray to lay in the shadows and the dark areas of the armor. Using Yellow Ochre, Naples Yellow Italian and Burnt Umber, start putting in the areas of the armor that are going to be gold. Use Yellow Ochre to build up the forms of the painting, establishing the light as it falls on the armor and muscles of the ogre from above.

TECHNIQUE

THE EYE AND EYE AREA

When drawing the eye and the eye socket area, including the protruding brow, think about how the eye moves, opens and shuts. The lines of the eyelids should mirror the shape of the eye. The brow should protrude over the eye and eye socket. Use shading to create a shadow below the brow and above the eye. The wedge shape just below the eye is the bottom of the eye socket. This area is sunken causing this line. All of the lines used to make creases and wrinkles in the ogre's skin are heavier and look deeper because the hidelike skin of the ogre is so thick.

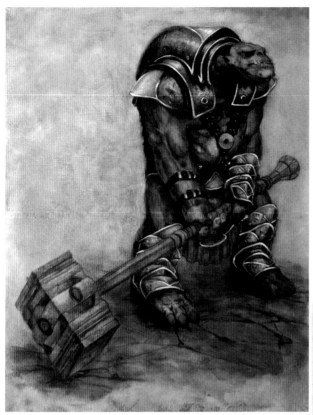

3 Block in the areas of the armor, and wash a warm gray over the flesh. Use a cool gray made with Titanium White, Ivory Black and Cobalt Blue on the armor. The warm gray for the flesh of the ogre is a mixture of Titanium White, Ivory Black and Burnt Umber.

Continue using the cool gray on the armor, lightening and darkening it to accent the forms. For the highlights, take a little of the cool gray and mix it with Titanium White. Continue using Naples Yellow Italian, Yellow Ochre and Burnt Umber to finish up the gold areas of the armor. Mix a bit of Naples Yellow Italian with a lot of Titanium White for the highlights in the gold areas.

4 Use the armor palette to paint the hammer. Switching over to the flesh, skin and muscles of the ogre, use the warm gray from step 3, Burnt Umber, Titanium White, Yellow Ochre and Burnt Sienna. Continue to build the forms using the gray mixture and Yellow Ochre for the middle tones, Burnt Umber in the shadows and Titanium White with a touch of warm gray for highlight areas. Add Raw Sienna to indicate thinner areas of the ogre's skin. Start adding details like scars and veins. Now you are ready to paint in the background with Titanium White.

Finish up the stones on the ground with Raw Sienna, Burnt Sienna, Van Dyke Brown, Burnt Umber and Yellow Ochre. Don't forget the shadow cast on the ground by the ogre. Add the final highlights on the armor with a mixture of Titanium White with a hint of light blue. To finish the ogre, paint in the highlights with a light version of the warm gray and Titanium White mixed with a small amount of Yellow Ochre (this mixture should still be almost white). Bring on his enemies—this ogre is armed for battle.

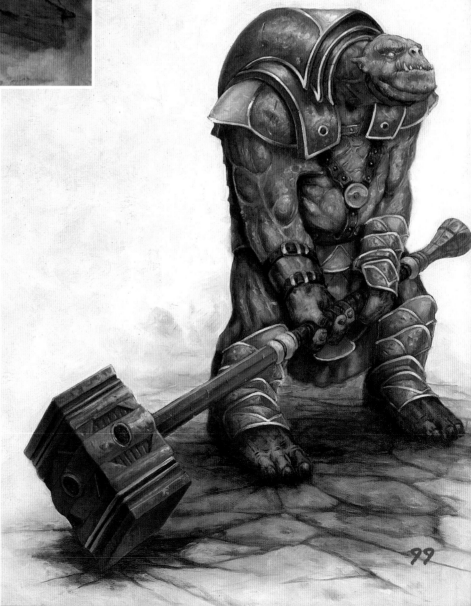

VENUSIAN

Evolved from ancient space spores, Venusians are large, carnivorous plant creatures that can eat a human being alive. They are mind-less automatons that will resort to cannibalism in times of drought, although they do have a sense (if somewhat limited) of hunting strategy. Venusians hypnotize their prey with shining tendrils and an irresistible pheromone that pools in their mouths. They tend to multiply in remote swamps and dark forests. If not eradicated, Venusians can cover large fields, attracting whole forests of animals and cities of people.

SMELL OF DEATH

HYPNOTIC EYES

POOLING PHEROMONE

VENUSIAN CHARACTERISTICS

A cross between plant and insect, Venusians are anatomically simple, and there is room for plenty of improvisation in drawing their features, which include:

�֍ A big clam-shaped head.

✖ Long, fingerlike, luminous tendrils.

✖ A slimy round body with protruding, multi-branched roots.

✖ A long neck that can expand and contract like a snake when eating large prey.

THE SMELL OF DEATH

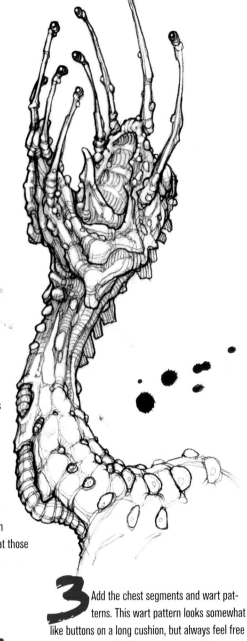

1 Begin the basic shape of the Venusian's neck craning to the sky with an upward gesture. Its jaws are wide open, emitting the smell of death produced by the pheromone pooling in its mouth. Add the major shapes, including the clamshell head, tendril stalks and bulges in the neck. Think of each tendril stalk as if it were a finger with small knuckles.

2 Continue adding more details and shapes along the body. The ridges and warts along the chest and neck should appear to have the ability to expand and contract around its prey. Sketch in the fleshy maw and tongue, and start detailing the ridges of the upper palate. Leave a space in the gums for each "tooth" stalk; this gives the impression that those jaws would fit right together when closed.

3 Add the chest segments and wart patterns. This wart pattern looks somewhat like buttons on a long cushion, but always feel free to experiment with different textures and patterns. Finish by adding in the rest of the shadows and highlights. The main light source is shining from directly above, so the major shadows will fall on the neck and directly below the folds of skin. The highlights will shine from the tops of each shape.

VENUSIAN WEAPONRY

Venusians have very little defensive armor. Although their skin is layered and thick, it is no match for an axe or sword. Their luminous tendrils and the ability to hypnotize are the Venusians' best defense.

HYPNOTIC EYES

1 Begin with some basic shapes to define both the Venusian and its prey. Draw the big Venusian head with goggly eyes, the roots, and the head, shoulders and hand of the prey. Pay special attention to how arms flail or finger muscles clench when you're sketching a corpse or a creature contorted in pain.

2 Flesh out more of the detail. Determine where shadows will fall. The light source is coming from the front left, so each shadow will fall to the right and behind the object that is casting it. Define more of the man's armor by adding studs to the leather covering the shoulders. Add in the Venusian's stretched nostrils and bulged eyeballs.

3 Tighten everything up. Add a snakelike pattern to the top area of the Venusian's head as well as the main ground shadow done in a texture of small pebbles. Outline the major shapes, adding shadows and creating highlights with your eraser to make the forms more three-dimensional.

UP CLOSE AND PERSONAL

Get a magnifying glass and examine plants up close. Notice the different ways in which fibers support and move the structures toward the light. In the springtime you can get out and see how plants grow, and then in the fall you can watch how they decay.

DRAWING DEMONSTRATION

1 Begin by roughing in the basic gesture sketches capturing the shapes of all the Venusians: the heads, necks, fingerlike stalks and roots. Play with the chaotic vapor shapes that form above the mouth openings. This might take some erasing and resketching, but settle on something that looks believable. Then contain the whole sketch with a frame, leaving some parts poking out.

2 Start completing most of the details on the heads. Draw in a lot of warts and wrinkles. It will make the heads and necks look dark in contrast to the light of all that vapor. Start sketching the chest plate design along a guideline running up the center of each Venusian's neck.

TECHNIQUE

PRESERVING THE GESTURE SKETCH

There are many times when you might wish you'd not painted over or drawn over parts of a sketch, as the original gesture drawing has become lost. There is often a certain freshness or directness that you nail down in a thumbnail that simply can't be improved upon. I fell in love with the original concept sketch, the way the main Venusian's head is posed in a lilting, silly manner.

1 You can preserve the gesture sketch best by covering the original sketch with another sheet of layout or tracing paper so that you can see it directly as you sketch on top of it. Look at the original often as you sketch to make sure you're not straying too far from what you liked about the original.

2 Tape a piece of layout paper to step 1 and look at step 2 while you work. Notice that there are slight differences in the eyelids and in the symmetry of the tendrils, but by and large the gesture sketch of the face has been preserved in the final drawing.

TIPS

- Use a strong paper that will hold up to erasing.

- Keep a couple of pencils around; once one goes dull, use it for thick outlines, and switch over to a sharp one.

- Place a plain sheet of paper under your drawing hand to avoid excessive scumbling.

- Use an eraser to make highlights.

- Use a scanner or digital camera and computer to manipulate your sketch. I mostly use the computer to print and transfer the final sketch on to illustration board, but I'll also use it to erase out highlights that are too small to get by hand or to stretch body parts to make a better design.

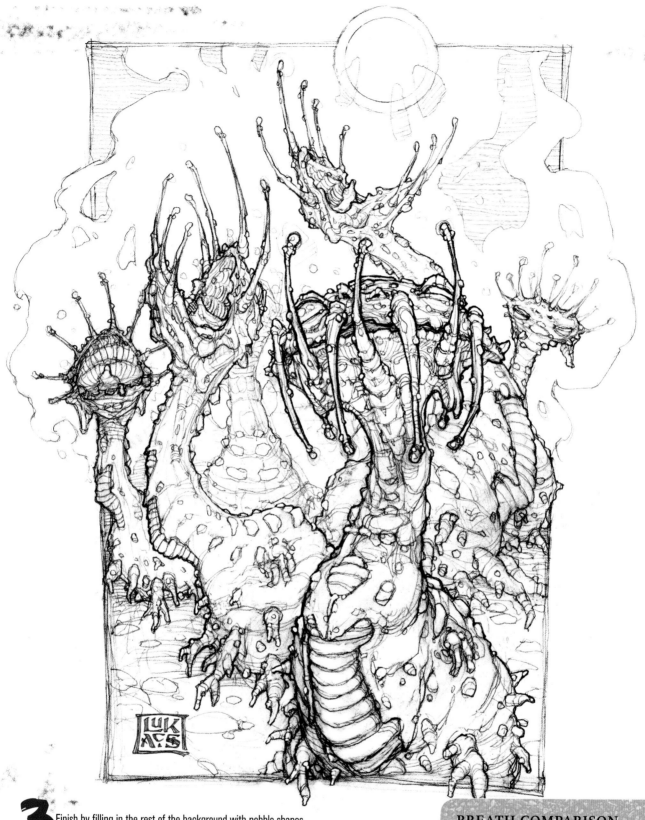

3 Finish by filling in the rest of the background with pebble shapes and shading in the night sky. Outline and shade the foreground Venusians. Foreground characters should be shaded darker than the ones in the background. The central Venusian character in front has the darkest shading and the greatest attention to detail.

BREATH COMPARISON

The vapor of the Venusian's breath is much more lofty and foglike than the shooting dragon's breath (see page 86).

MINOTAUR

The Minotaur's size and speed make him an intimidating foe. Usually on the front lines, these behemoths tear through enemy lines leaving their opponents scattered. Their thick skin can withstand a barrage of flaming arrows or a useless slash of an enemy's blade.

A Minotaur will not waste energy on "less than worthy" opponents (particularly short ones). It will walk right over a group of foot soldiers, going straight to the calvary in order to take out the horsemen who pose the greater threat. The word "retreat" does not exist in the Minotaur's vocabulary (what little vocabulary there is); victory on the battlefield is the only true honor. The Minotaur would much rather sacrifice himself for the betterment of a military campaign than walk away in defeat.

MINOTAUR CHARACTERISTICS

✠ A Minotaur is gigantic—12' (3.7m) and just as wide.

✠ It has thick skin that can withstand arrows and the sword.

✠ It has oversized limbs, perfect for walking over and crushing lesser enemies.

✠ The Minotaur moves with extraordinary speed, especially for its massive size.

SIX-FOOT SWORD

OVERSIZED LIMBS

SKULL SHIELD

105

SKULL SHIELD

1 Draw an oval and then draw another oval in the center of the first oval. The second oval will indicate where you are going to place the skull that gives this shield its name.

2 Add some edge lines. This will begin to establish the thickness of the shield. I made it just thick enough to withstand a sword blow. Don't make it too thick, or the Minotaur won't be able to carry it into combat!

3 Next, draw the skull in the smaller oval. I made his mouth open like he's caught in an eternal scream. Yikes! Draw tiny circles beneath the skull and add strands of hair and a braid (souvenirs from vanquished foes). Then, draw lines for the wooden boards that form the shield. Add a reinforcing steel bar on each side of the shield. Then, draw the handle.

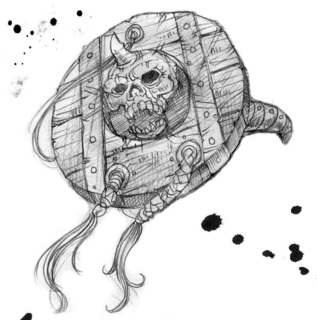

4 Erase any pencil marks that you don't want in the finished drawing. Draw the bolts to hold the reinforcing steel bars in place. I added a horn to the center of the skull just for fun! Finally, create the wood grain texture with uneven lines that mimic the wood fibers' growth patterns. Now our Minotaur can bust through those front lines!

SIX-FOOT SWORD

1 Draw the basic shape of the sword and pommel. The sword is about half the height of the Minotaur. The back of the sword is the flat, dull side. The front is the curved, sharp side. Add a circle for the pommel. Create the basic shape of the hand holding the sword. Draw a square for the palm of the hand and an oval for the thumb.

2 Draw an obtuse triangle on the dull side of the sword. Curve the sides so that they become flush with the flat side. Then, draw a curved notch on the lower part of the sharp side. Draw the fingers (just three!) and thumb wrapped around the pommel.

3 Now, draw the hilt and the finger guard. The hilt's thickness depends on how thick you want the finger guard. Draw spikes on the finger guard. I'm adding a severed head to the spikes—just another souvenir from the battlefield! Draw an oval with a cross through it to establish the center of the face. Add spikes to the pommel of the sword, and draw some cracks on the sharp side of the blade. Then, add fingernails to the thumb and any other visible fingertips.

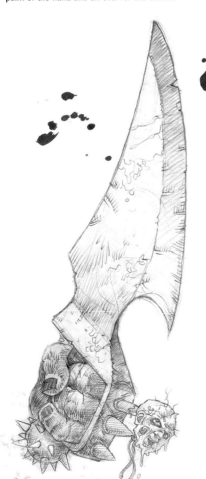

4 Erase any unwanted pencil marks. Draw a second line that curves with the edge of the blade on the sharp side of the sword to make the sharpness more apparent. Add more scrapes and cracks to the sharp edge. Next, draw the face on the severed head. Make his eyes look sunken by drawing dark rings around them. Add circles for the pupils. To make the head look like it's been there for a while, draw a ragged line around the contours of the face. Draw the detail on the fingers and thumb—this Minotaur could use a manicure. But I wouldn't get near him while he has a sword as tall as I am in his hand!

WEIGHTY WEAPONS

Think of the Minotaur as a tank—thick-skinned and armored! Would his weapons hinder his speed or would they help in cutting down the enemy? Would your Minotaur even wear armor or is he strong enough to go without?

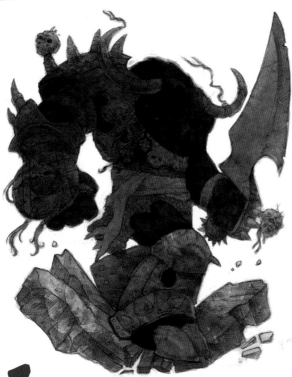

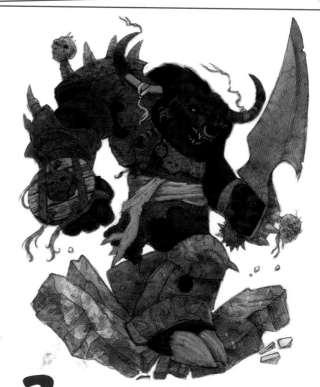

1 With a ½-inch (12mm) flat, block in the underpainting with acrylic in earth tones. I used Yellow Ochre as a basecoat and combined Burnt Umber and Burnt Sienna for the fur and armor underpainting. I used Higgins Violet ink for the crushed rocks and the chain mail tunic. Don't worry too much about getting a little paint outside the lines. You can always tighten up your edges with white acrylic paint.

2 Using your acrylic wash as a guide, continue blocking with oil paint. I began with the warm fur elements. Start thinking about lighting and its effects. Working with earth tones (from dark brown to light brown), complete one area at a time rather than going back and forth. Create these mixtures with Burnt Umber, Burnt Sienna and Yellow Ochre. Make a dark mixture of Burnt Umber and Burnt Sienna for the fur. Mix Titanium White with Burnt Umber, Burnt Sienna and Yellow Ochre to create a dirty color for his teeth and eyes. Don't worry about the details yet—they'll come later.

TECHNIQUE

PAINTING FUR

1 Start by blocking in a wash. I used diluted acrylic Burnt Umber and a ½-inch (12mm) flat.

2 Start with your darkest color and paint, with a no. 3 round, in the direction of your form. Hair grows in one direction, usually downward or outward, and follows the contour of the body.

3 Here I applied my darker color in the area where I blocked in color earlier, allowing the blocking color to show through as a separate color.

4 With a no. 2 round, apply the lightest parts of the fur. Use a mixture of Yellow Ochre, Burnt Sienna and Titanium White. Since the Minotaur's fur grows in short layers, the highlighted fur would be closest to the light source.

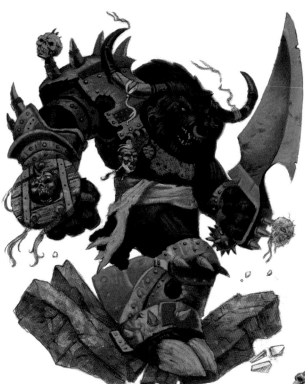

3 Establish warm and cool color groupings. I started with the armor and all the other elements that are steel gray. Mix Burnt Umber, Phthalo Blue and Titanium White in different ratios to create cooler and warmer grays (add more Phthalo Blue for the cooler mixture and more Burnt Umber for the warmer mixture). Start to think about the imperfections you might want in the armor and weapons.

The other color groupings include yellow, brown and purple. For the yellow, mix Yellow Ochre, Titanium White and Burnt Umber. The purple mixture is a combination of Dioxazine Purple, Phthalo Blue and Titanium White. For the brown mixture, combine Burnt Umber, Burnt Sienna, Yellow Ochre and Titanium White.

Now that you have established color groupings, start to work over the initial paint layers. Work an entire area at once. With a no. 2 or no. 3 round, start working in some of the details on the face, hands and armor.

4 Now that you've established all the midtones, push and pull the elements that you want to really punch out by adding the dark darks, light lights and backlighting. Backlighting is reflected light coming from other objects in your painting. You can see this effect on the Minotaur's right underarm. Finish by going over every element with a fine tooth comb (brush actually). Use a no. 1 or no. 000 round to add the smallest details such as the hints of light on the chain mail tunic or on the underside of the shield nails. Once you have established the blocking and lighting you can get in there and work those details 'til your heart's content. Let's wreak havoc!

TIPS

- Mix up enough oil paint and try to cover larger areas of color all at once rather than remixing and going back and forth.

- Start with big areas of color and finish with small details of color.

- Don't be afraid to experiment with mixing oil color . . . you might end up with a new color for your painting.

- Think in terms of warm and cool colors when working in oil paint.

- Practice, practice, practice, practice, practice, practice, practice! The more you practice the more familiar you'll become with your tools and their capabilities.

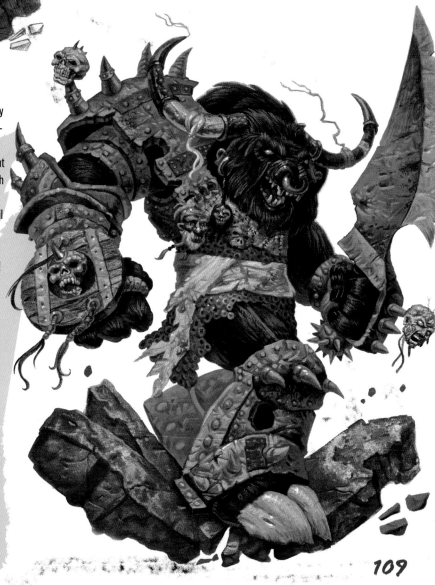

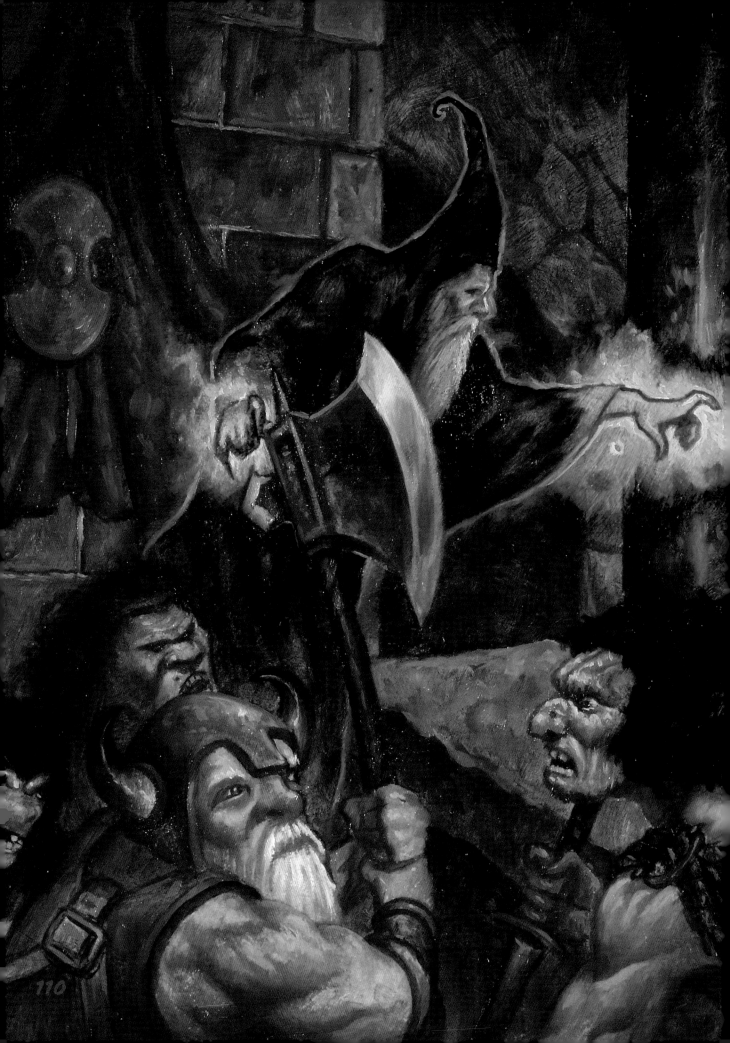

CHAPTER 5
ENVIRONMENTS

We approach the end of our journey, and there through the turpentine and pencil shavings we see our adventurers home to their environments once again. Look at how they shape their habitats, and how their habitats can shape them. Some of them are peaceful and quiet, others bustling with the noises and the smell of industry. Enjoy your newfound skills. Experiment and practice every chance you can, and share your fantastic worlds with your friends and family.

"Roads go ever ever on,
Over rock and under tree,
By caves where never sun has shone,
By streams that never find the sea"

—J.R.R. TOLKIEN
***THE HOBBIT**, 1937*

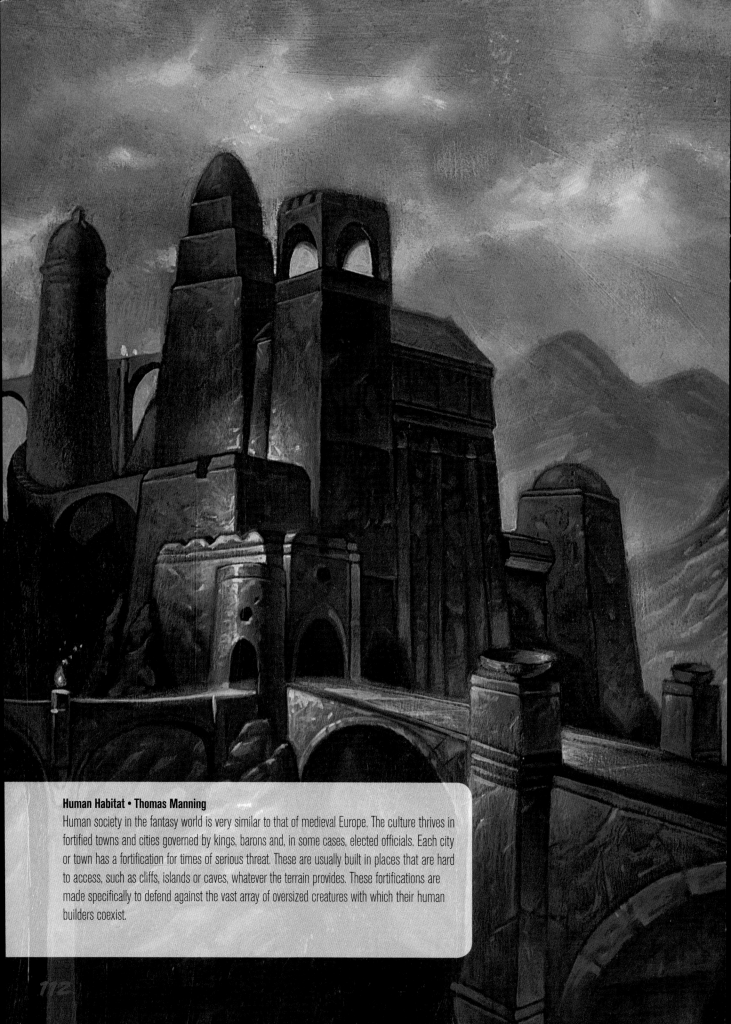

Human Habitat • Thomas Manning

Human society in the fantasy world is very similar to that of medieval Europe. The culture thrives in fortified towns and cities governed by kings, barons and, in some cases, elected officials. Each city or town has a fortification for times of serious threat. These are usually built in places that are hard to access, such as cliffs, islands or caves, whatever the terrain provides. These fortifications are made specifically to defend against the vast array of oversized creatures with which their human builders coexist.

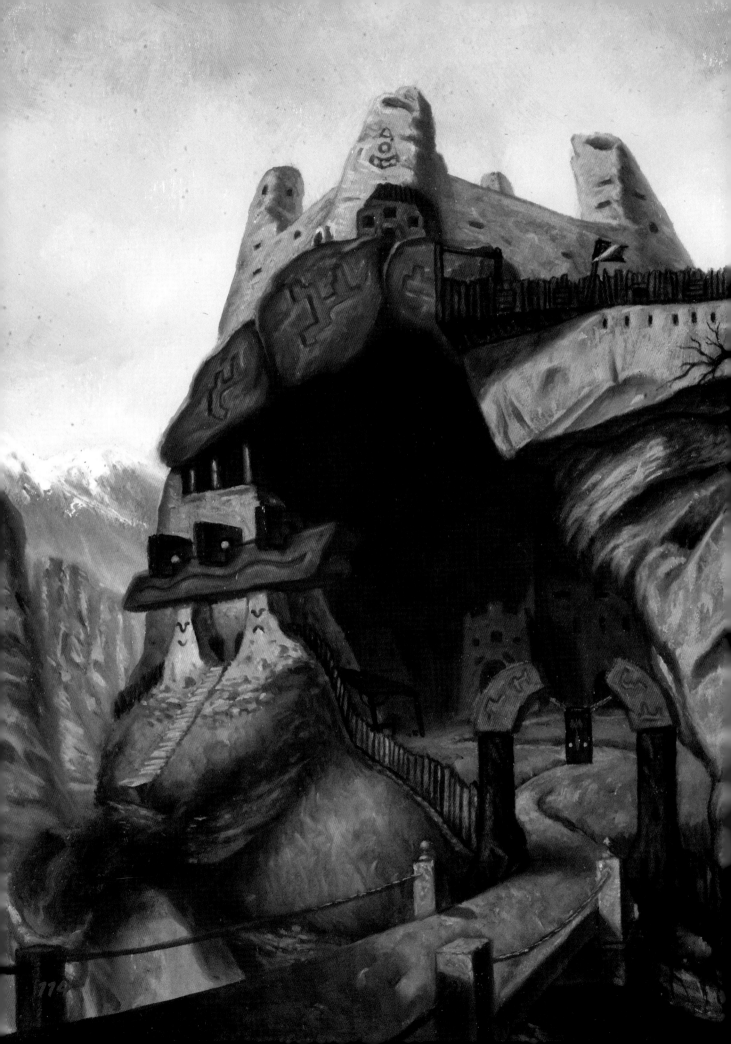

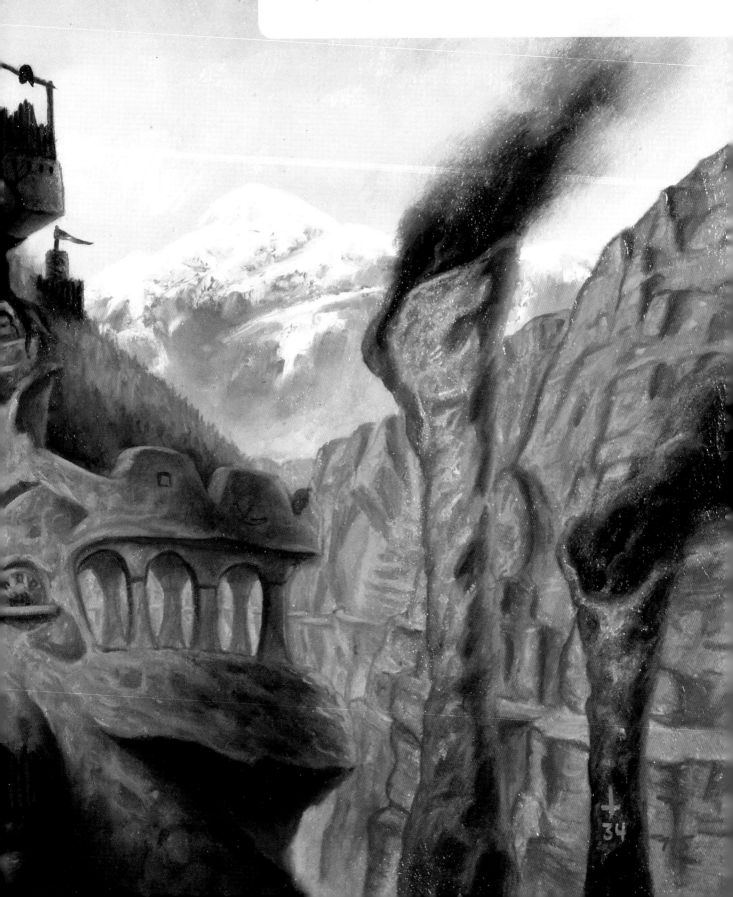

Orc Otherworld • Jim Pavelec
With their understanding of mechanics and leverage, orcs are able to build impressive dwellings and fortresses. Aesthetics are not the most important factors in their buildings and day-to-day items. They are scavengers and use what they can from the land or from the spoils of war.

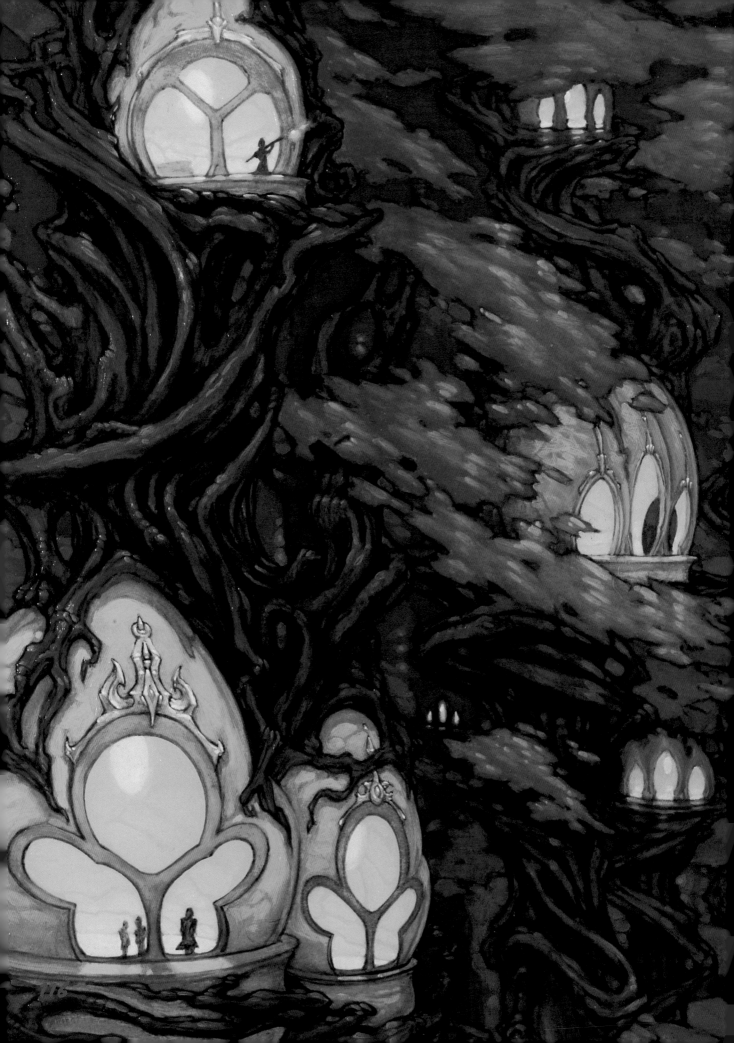

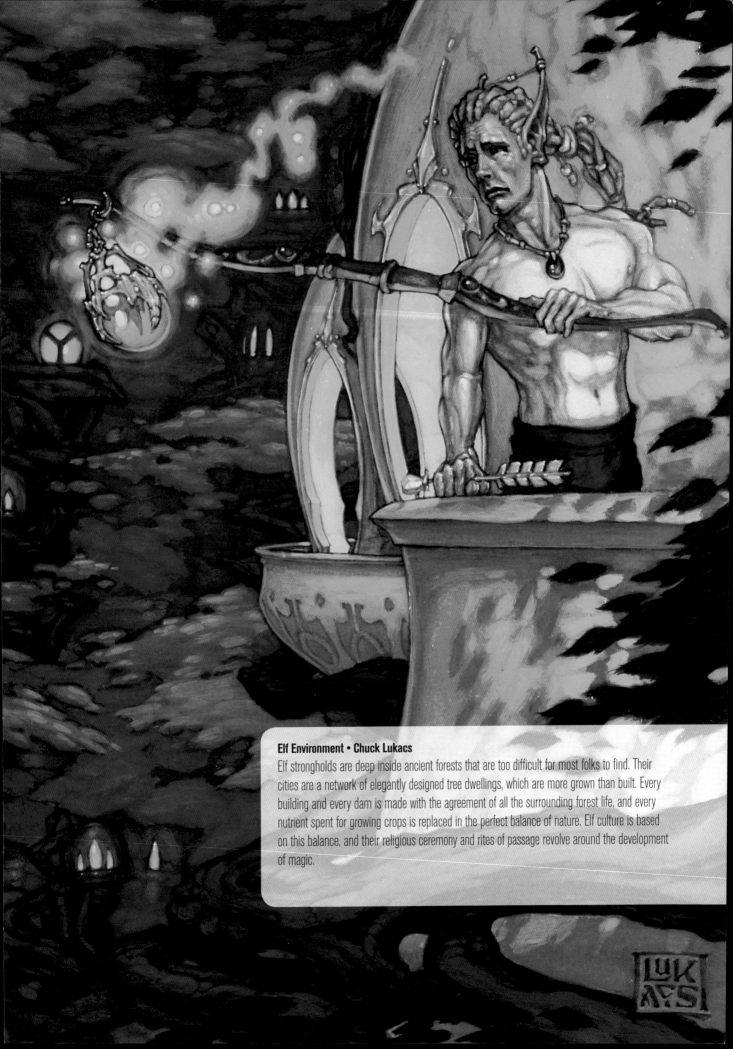

Elf Environment • Chuck Lukacs

Elf strongholds are deep inside ancient forests that are too difficult for most folks to find. Their cities are a network of elegantly designed tree dwellings, which are more grown than built. Every building and every dam is made with the agreement of all the surrounding forest life, and every nutrient spent for growing crops is replaced in the perfect balance of nature. Elf culture is based on this balance, and their religious ceremony and rites of passage revolve around the development of magic.

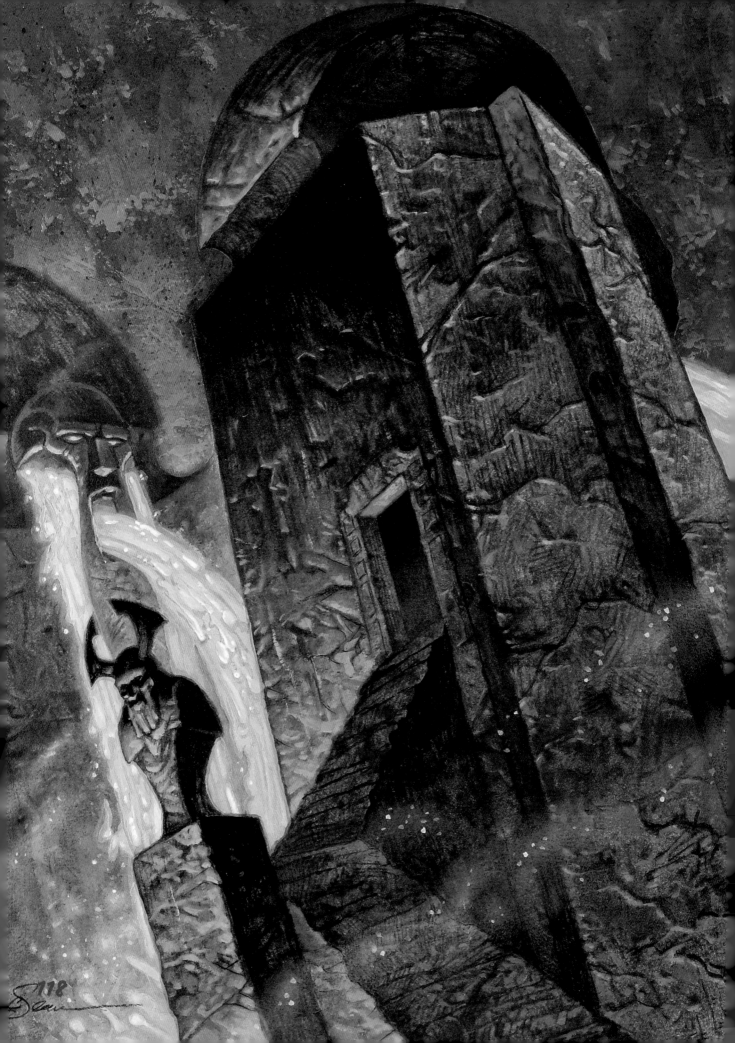

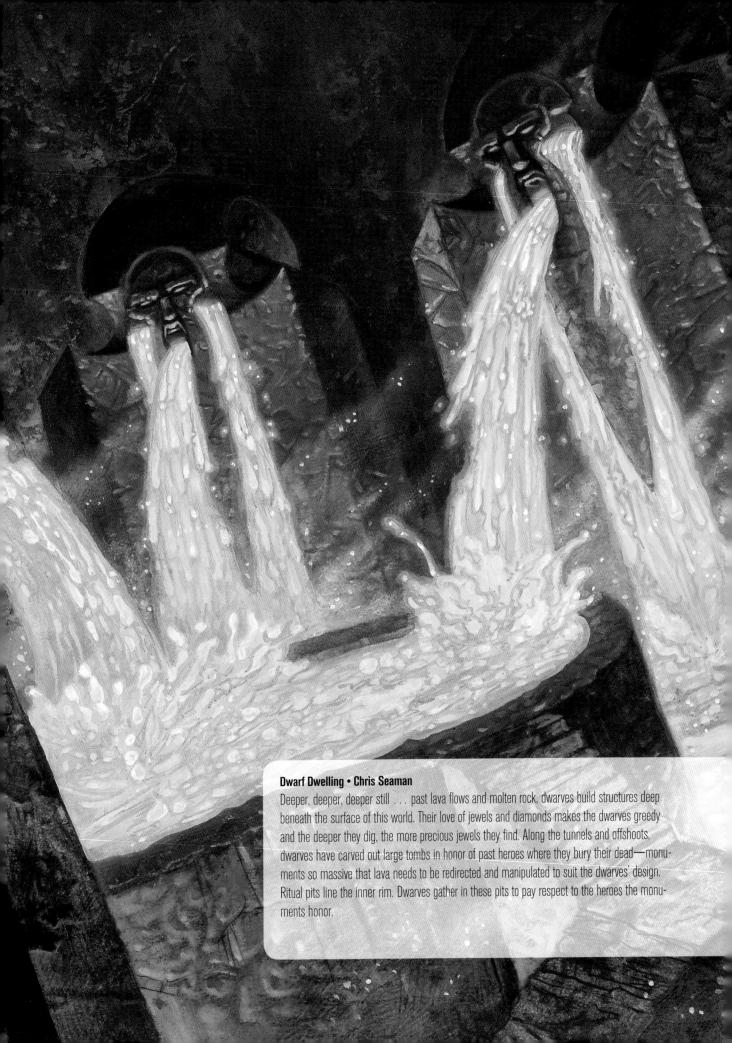

Dwarf Dwelling • Chris Seaman

Deeper, deeper, deeper still . . . past lava flows and molten rock, dwarves build structures deep beneath the surface of this world. Their love of jewels and diamonds makes the dwarves greedy and the deeper they dig, the more precious jewels they find. Along the tunnels and offshoots, dwarves have carved out large tombs in honor of past heroes where they bury their dead—monuments so massive that lava needs to be redirected and manipulated to suit the dwarves' design. Ritual pits line the inner rim. Dwarves gather in these pits to pay respect to the heroes the monuments honor.

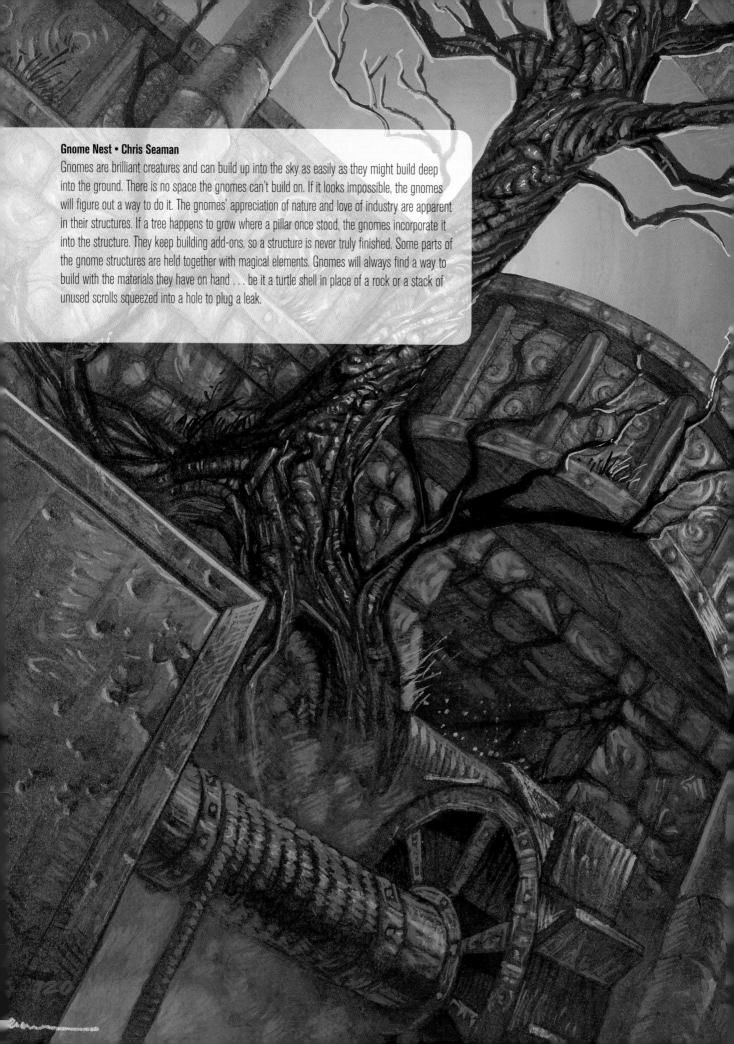

Gnome Nest • Chris Seaman

Gnomes are brilliant creatures and can build up into the sky as easily as they might build deep into the ground. There is no space the gnomes can't build on. If it looks impossible, the gnomes will figure out a way to do it. The gnomes' appreciation of nature and love of industry are apparent in their structures. If a tree happens to grow where a pillar once stood, the gnomes incorporate it into the structure. They keep building add-ons, so a structure is never truly finished. Some parts of the gnome structures are held together with magical elements. Gnomes will always find a way to build with the materials they have on hand . . . be it a turtle shell in place of a rock or a stack of unused scrolls squeezed into a hole to plug a leak.

CONCLUSION

Like all of the beings in this book, now you, too, are equipped to wreak havoc. As your weapons, you have a knowledge of shape, light and shadow, gesture, texture and design. Will you take up the mantle of a true warrior and practice every day? Will you wear the edge of your pencil down, beating it against the enemy, that stark white piece of paper?

Early on, you learn by copying. All of the great Renaissance masters copied the forms of classical Roman and Greek sculpture and tried to imitate the painting techniques of their predecessors. When we were very young, the four of us started out by copying the works of our heroes.

It's not enough, though, to just copy the designs in this book. You must venture out on your own, and create your own unique point of view on the archetypes, humanoids and monsters that exist in a fantasy setting. You must create your own style and set yourself apart from your fellow artists. Chris, Chuck, Thomas and I have been successful in the fantasy industry for this very reason. We all have the same basic set of skills and work in the same genre, but our styles are vastly different from one another.

Throughout this book, you've seen art that clearly demonstrates this point. Each piece delivers you into a world other than your own, a world rich with magic, creatures and wondrous landscapes. However, it would be impossible to confuse one person's work with another's. We each have made bold decisions on our artistic paths that have made our work identifiable as ours and ours alone.

This is one of the most difficult parts of becoming an artist. It would be much easier to copy someone else's style, and do things the way he does. Throughout history, quite a few artists have made out very well doing just that. But you are better than that now. You are a wreaker of havoc. You will break down all resistance to your efforts and leave the works of lesser artists in your wake. You will develop a way of drawing and painting that will make others say, "*Wow*. I wish I could do that."

Go forth, my young warrior, and unleash your havoc upon the land.

—JIM PAVELEC

CHRIS SEAMAN
DWARVES' DESCENT
© Alderac Entertainment Group 2006

JIM PAVELEC
AN ONI'S REFUGE

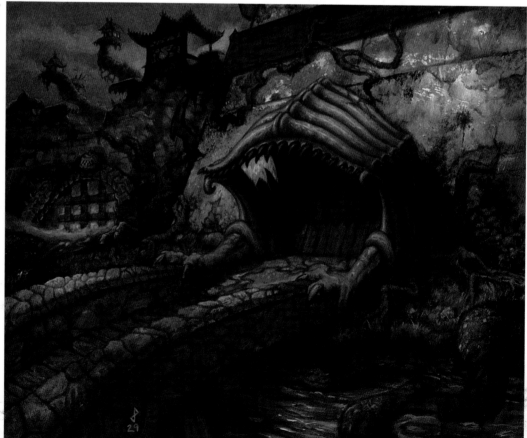

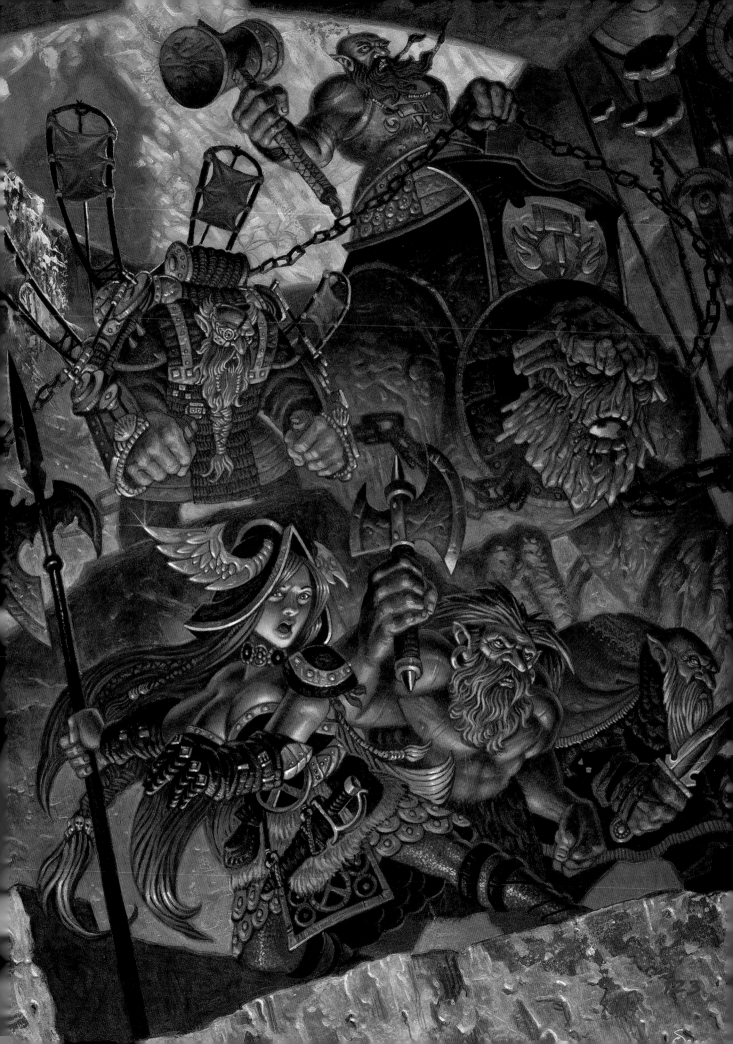

THOMAS MANNING
PARASITE ONI

CHUCK LUKACS
PSIMATES

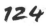

CHUCK LUKACS
WARCHIEFS OF THE APOCALYPSE

A Band of Orcs © used with permission

CHRIS SEAMAN
DOOM!

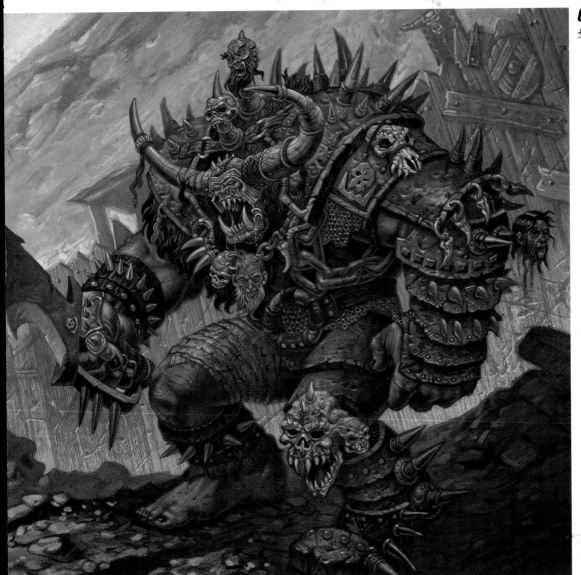

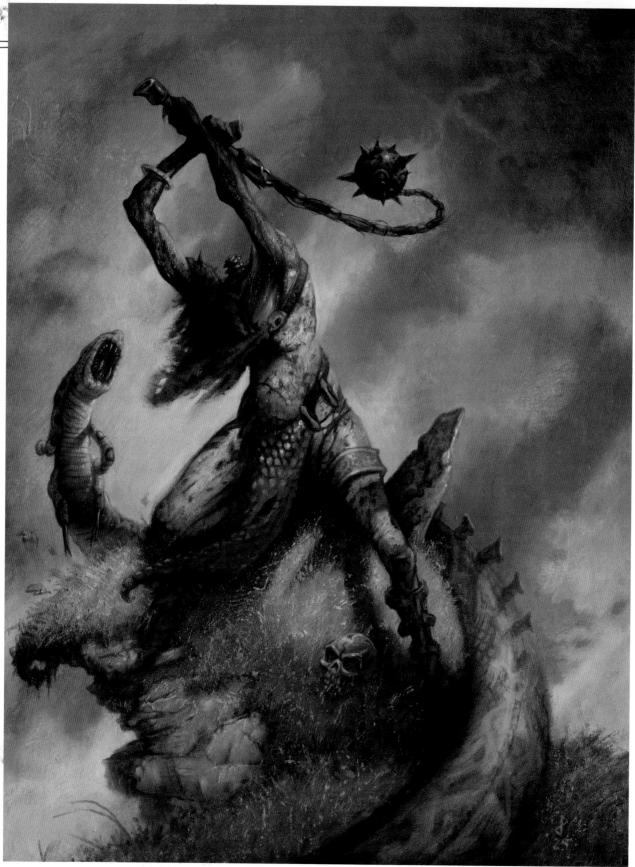

JIM PAVELEC
UNDEAD

INDEX

METRIC CONVERSION CHART

To convert	to	multiply by
Inches	Centimeters	2.54
Centimeters	Inches	0.4
Feet	Centimeters	30.5
Centimeters	Feet	0.03
Yards	Meters	0.9
Meters	Yards	1.1

IF YOU'RE GOING TO DRAW—
DRAW WITH **IMPACT!**

"Here's how I do it, and why." This is the premise behind, *Lord of The Rings* concept artist, John Howe's very first practical exploration of his artistic inspirations, approaches and techniques. Perfect for practicing artists and fans of Howe's work, this book provides step-by-step demonstrations, sketches and outstanding finished paintings. The book covers a wide range of subjects essential to any aspiring fantasy artist, including materials and the creative process, as well as drawing and painting humans, beasts, landscapes and architecture. You'll also find further inspiration and guidance on presenting work in various forms including film work, book covers and advertising.

ISBN-13: 978-1-60061-010-3
ISBN-10: 1-60061-010-2
PAPERBACK, 128 PAGES, #Z1044

Unleash hell with top gaming artist Jim Pavelec. Progressing from the basic to the more intermediate, you'll find everything you need to start drawing a plethora of gruesome creatures. The book covers tools, setup, references and getting started, and features over 25 step-by-step demonstrations for drawing a variety of fearsome beasts including demons, goblins, zombies, Minotaurs, hydras and more.

Hell Beasts examines the skeletal structure, musculature and organic features of monsters, allowing you to achieve realistic looking results. Filled to the teeth with examples and step-by-steps, and stunning—well, shocking—examples, this book is sure to teach you the stuff nightmares are made of.

ISBN-13: 978-1-58180-926-8
ISBN-10: 1-58180-926-3
PAPERBACK, 128 PAGES, #Z0569

Fantasy Characters takes you from the skies to the ground and shows you how to draw everything in between. Populate your art worlds with every walk of life including: dwarves, elves, orcs, goblins, merfolk, fauns, centaurs, werewolves, vampires and more! Includes many of the fun features of Peffer's first book *DragonArt: How to Draw Dragons and Fantasy Creatures* such as historical facts about fantasy people, a cool flipbook feature on the bottom right-hand pages and the book mascot, Dolosus.

ISBN-13: 978-1-58180-852-0
ISBN-10: 1-58180-852-6
PAPERBACK, 128 PAGES, #Z0055

These books and other fine IMPACT titles are available at your local fine art retailer or bookstore or online suppliers. Also visit our website at www.impact-books.com.